PHOTO THERAPY MOTIVATION AND WISDOM

DISCOVERING THE POWER OF PICTURES

PICTURE BOOKS BY RICK SAMMON

Creative Visualization for Photographers
Evolution of an Image
Exploring Photographic Exposure
The Route 66 Photo Road Trip with Susan Sammon
The Oregon Coast Photo Road Trip with Susan Sammon

PHOTO THERAPY MOTIVATION AND WISDOM

DISCOVERING THE POWER OF PICTURES

RICK SAMMON

Cover design by Ivica Jandrijevic
Interior layout and design by www.writingnights.org
Book preparation by Chad Robertson
Edited by

ISBN: 978-168-8297340
Library of Congress:
LIBRARY OF CONGRESS CATALOGING-IN-PUBLICATION DATA:
NAMES: Sammon, Rick, author
TITLE: Photo Therapy Motivation and Wisdom – Discovering the Power of Pictures / Rick Sammon
DESCRIPTION: Independently Published, 2019
IDENTIFIERS: ISBN 978-168-8297340 (Perfect bound) |
SUBJECTS: | Non-Fiction | Photography | Philosophy |
Motivation | Inspiration | Travel Photography
CLASSIFICATION: Pending
LC record pending

Printed in the United States of America.
Printed on acid-free paper.

Disclaimer A: Any legal advice herein is offered solely as the opinion and research of the author, and it is strongly advised that any legal questions be directed to a bona fide attorney.
Disclaimer B: As with any book that deals with technology, it will always run the risk of making references to companies or technologies that have already ended up in the dustbins of history. Once-dominant brands of today can quickly be the forgotten brands of tomorrow. The author has kept the information as contemporary and up-to-date as possible up until the date of publication. However, the author recognizes that current internet giants could completely vanish from the online environment.

24 23 22 21 20 19 18 17 8 7 6 5 4 3 2 1

Dedicated to my wife and best friend Susan Sammon, who has encouraged me with everything I have done since 1973.

Susan, when given the choice of being right or kind, is always kind. She is also the person who returns the supermarket cart to the cart area. Every time.

There is much to learn from Susan Sammon, a wonderful iPhone photographer and instructor, by the way. Susan took the back cover photograph of me while we were in Sri Lanka.

It's never too late to be what you might have been.
– GEORGE ELIOT

CONTENTS

PICTURE BOOKS BY RICK SAMMON ... ii

DEDICATION ... v

CONTENTS ... vii

FOREWORD .. xi

PREFACE ... xv

AUTHOR'S PREFACE ... xix

ACKNOWLEDGEMENTS ... xxv

INTRODUCTION ... 1

PROLOGUE ... 3

1. WHAT DOES YOUR PHOTOGRAPHY MEAN TO YOU? 7

 YOUR MISSION: ... 10

2. BECOMING AN ARTIST AND NEVER GIVING UP 11

 YOUR MISSION: ... 14

3. PHOTOGRAPHY CAN IMPROVE YOUR HEALTH AND SENSE OF
 WELL-BEING ... 15

 YOUR MISSION: ... 19

4. GETTING IN TOUCH WITH NATURE ... 20

 YOUR MISSION: ... 23

5. EXPERIENCING THE CIRCLE OF LIFE ... 24

 YOUR MISSION: ... 25

6. CREATING YOUR OWN REALITY ... 26

 YOUR MISSION: ... 36

7. LOOKING VS. SEEING .. 37

 YOUR MISSION: ... 45

8. LEARNING IS HEALTH..46

 YOUR MISSION:...49

9. PHOTO THERAPY AND SOCIAL MEDIA...............................50

 YOUR MISSION:...52

10. GROUP PHOTO THERAPY ..53

 YOUR MISSION:...61

11. EMOTIONAL INTELLIGENCE FOR PHOTOGRAPHERS.................62

 YOUR MISSION:...66

12. THE THERAPEUTIC PROCESS OF IMAGE PROCESSING...............67

 YOUR MISSION:...71

13. STEAL LIKE AN ARTIST ...72

 YOUR MISSION:...73

14. WRITE A CAPTION OR EVEN A BOOK.................................74

 YOUR MISSION:...79

15. IT'S NEVER TOO LATE TO BE WHAT YOU MIGHT HAVE BEEN.80

 YOUR MISSION:...81

16. THE POWER OF A PICTURE ...82

 YOUR MISSION:...88

17. THE HARDER YOU WORK, THE LUCKIER YOU BECOME............89

 THE FIRST STORY ...90
 THE SECOND STORY..91
 YOUR MISSION:...93

18. LIGHT THERAPY, COLOR THERAPY, AND COLOR BLINDNESS.94

 YOUR MISSION:...98

19. SOME THOUGHTS ON BEING A PURIST...............................99

 YOUR MISSION:...101

20. MY 40 SAMMONISMS AND ALL QUOTES102

 YOUR MISSION:...115

21. WITH A LITTLE HELP FROM MY FRIENDS..........................116

STEVE BRAZILL: *IT'S THE ART THAT DEFINES US*....................................116
RON CLIFFORD: *IT'S NOT ABOUT THE CAMERA*119
DERRICK STORY: *JUST OUTSIDE OUR DOOR*122
RANDY HANNA: *PHOTOGRAPHY IN THE "FLOW STATE"*.....................126
YOUR MISSION: ..128

22. YOUR MISSION, SHOULD YOU CHOOSE TO ACCEPT IT......... 129

ASK YOURSELF,
"WHAT DOES YOUR PHOTOGRAPHY MEAN TO YOU?"131
NEVER GIVE UP ..131
STAY HEALTHY AND KEEP FIT ...131
CONSIDER THE SPACE-TIME CONTINUUM...131
PHOTOGRAPH ANIMALS..132
CREATE YOUR OWN REALITY ..132
THINK ABOUT MY ONE-PICTURE PROMISE ..132
FOLLOW YOUR HEART AND ENJOY THE PROCESS...................................132
STEAL LIKE AN ARTIST...132
BELIEVE IN YOU..132
LOSE THE LEASH ..133
TAKE A PICTURE EVERY DAY ...133
WRITE ...133
GO BACK ...133
JOIN FOR THE JOY ..133
CHANGE IT UP ...133
HAVE FUN ...134

APPENDIX: ONLINE CLASSES WITH PICTURES!.................................. 135

DAYS IN MY LIFE.. 137

WHAT'S NEXT?... 139

FOREWORD

Rick Sammon and I are alarmingly simpatico; we must have known one another from a previous life. We get along so well that, maybe, in that previous life, we were actually married. The only reason I think this is because I get overly annoyed when he leaves the toilet seat up.

No, actually, more seriously, I think we get along so well because we have a rather deep connection about the meaning of photography. We get all wrapped up in the emotional and spiritual context of the creative process. To me, this is a much more interesting pursuit, this idea of finding one's true calling through photography. It's all quite philosophical, of course, but the nature of thinking about thinking is a noble endeavor, fraught with confusion, self-doubt, and, ultimately, self-fulfillment. Rick and I share these same fundamental tenets. They are hard to explain, but Rick has an excellent grip on this because he's been through the entire struggle, from alpha to omega. They don't call him the Godfather of Photography for no reason.

So, in this foreword, I wanted to give my own personal take on one of the best reasons to pursue a lifetime of photography: it makes life itself easier.

What? You ask. How can photography do that? To many, it appears that the life of a photographer can be one of the more difficult choices. It's the opposite of a predictable 40-hour-a-week job where you go sit

in a soulless box and make the sorts of decisions that are within some other pre-ordained box. The life of a photographer is chaos. Constant entropy. Constant mistakes. Constant self-doubt. Constant change.

And it's that change that is of paramount importance. I think of photography as a perfect proxy for life.

The daily life of a photographer is filled with countless questions and priorities. How do I answer this email? How much should I charge that person? What filter should I use on this photo? Should I upgrade to get that camera? If I buy that lens, how will it affect the use of my other lenses? Should I upgrade my website? Should I start a business Instagram too? Should I start figuring out more about blockchain? Should I stop wasting time on Flickr? How many hours a day should I engage in social media? Should I pay big bucks to join this workshop (P.S. If it's Rick's, then yes!)? Should I book out three more clients before I take a vacation to work on a personal photo project? Should I advertise on Facebook?

That's just a small sampling. Believe me, normal muggles with normal jobs don't have to think about any of that stuff. They just show up and have a fairly predictable day that is mostly full of order and very little threat of chaos.

Let's forget about photography for a hot minute here. Let's think about life.

Life is constant change. Constant chaos. Entropy abounds. You probably spend a decent part of your day just bringing a little bit of order to the chaos. Sometimes it's impossible, and you just feel like a tiny ship in the ocean as big waves batter you.

Loved ones in your family die. Relationships fall apart. Your kids act up. Your lawnmower breaks. You don't know what to eat for dinner. Sometimes it's easier to get under a blanket, turn on Netflix with some wine or chocolate, and escape.

I can tell you one thing for sure, however. Photographers are better suited to handle the chaos of day-to-day life because they have

embraced it as a professional lifestyle. I've only been taking photos for more than 10 years (Rick is closer to an order of magnitude more!), and I notice how much easier I am able to navigate the waters of real life. True, I'm a super-Zen guy. However, photography brought me to this place, a place where I don't take anything, especially myself, too seriously.

When you spend most of your day struggling with photography and all the questions I mentioned above (and a thousand more!), then you become one with the chaos. You are so used to dealing with entropic situations that you can bring these learnings to your real life. You begin to choose acceptance as a matter of course for the change you see. You accept that you have to upgrade your website fairly often. You accept that you have to figure out how to use new apps and new tools. You accept that change is a simple constant, and in fact a simple construct, of the universe. You don't fight it. You don't complain. Every "matter" that appears is not a problem, but a challenge. You go into the problem honestly, with humility, and do your best to figure it out.

Think about a lot of people you see on social media (especially Facebook) that complain about anything and everything. This is a not a good use of energy. A good use of energy is acceptance and then figuring out how to bend your life around any situation. Also, it's fun to notice that people that complain often have strong egos, and they are pointing out that the world is not going along with the story they are telling themselves. People that spend all day complaining have very little energy left over to create. This is yet another good reason to head into the arena of not taking yourself seriously, if not the all-out dissolution of the ego.

You already know that when you are "in the zone" and taking a photo (or even post-processing a photo), that you are completely present and mindful. You're not worried about the future or having self-doubt about the past. This is a beautiful place for creatives because they can give 100% of themselves to whatever is right in front of them. There is a pure acceptance here, and this is when creative people are at their best.

And sure, another wave will come along to throw you off your course. You will face more challenges and unknowns in photography than most other professions. However, this is a good thing. Unbeknownst to you, this is preparing you to have an easier life. You're much better prepared to deal with everything from serious problems in real life (the death of loved ones) to trivial problems (a broken lawnmower).

You learn to become the dolphin that swims in the waves.

And in this way, as you begin to ask the serious questions about your life, you'll see that photography will accidentally answer most of them for you. It's the perfect way for you to find your true self, to find your calling, to find out about yourself. Think about this in terms of reading books. There are two kinds of people that read books. One kind of person reads them so they can go to dinner parties and be interesting to other people. The other kind of person reads books so they are interesting to themselves.

I'll end this with a simple idea. We photographers are particularly drawn to light in all of its manifestations. Who knows why? We just simply seem to be attracted to light more than other people, even when we're not taking photos. We notice little things. The way a curtain might cut a shadow across the floor. The way a blue iris might fold light into itself. The way a child's skin has a glow without any filters. And as we all know, beautiful caverns can be created by the manner in which water flows through rock. I think there is a parallel with us. The light that flows through us carves our souls.

Trey Ratcliff
Stuckincustoms.com

PREFACE

I got so excited when Rick shared the concept for his latest book, *Photo Therapy Motivation and Wisdom: Discovering the Power of Pictures.*

I am a longtime follower of Rick's work. His approach to photography resonated with me, and I've attended his workshops around the globe. Once Rick discovered that I had practiced meditation for several years, and was also a certified meditation instructor, we began to engage in stimulating conversations on the intersection of photography and meditation.

My photography journey began when I got my first camera at the age of seven, and I embraced the camera as an instrument for documenting family history and events. My mother's interest in capturing moments inspired me; in fact, I still have her Argus film camera from the 1950s. In my teen years, I was known for packing a camera and I saved my meager earnings to upgrade from Kodak to Polaroid to a Minolta 35mm camera. Then life got in the way and I stopped taking pictures. Digital photography reignited my flame, but I longed to move my skills beyond snapshots.

Embracing Rick's motto of making versus taking photos set the tone for the next phase of my photographic journey. However, like many, the gear, controls, and all the technical stuff, kept getting in the way of the joy of actually taking pictures. As my investment in fancier, more

expensive cameras increased, the fun factor decreased.

One day it hit me that my favorite photos were those captured when I forgot about the gear and immersed myself in the subject. Those moments reminded me of my peak meditation experiences in that they took me out of my thoughts and I became fully immersed in the moment or subject. How does that happen?

Meditation is simply a practice where a person focuses their mind on a particular object, thought, or activity to achieve a mentally clear and emotionally calm state. There are various forms of meditation that range from sitting to standing, following the breath, repeating mantras, or staring at images. These techniques are designed to move you from the mind or thoughts and shift you to a state of calm and ultimately expanded awareness. Once in an expanded state, you see, feel, and envision things that the preoccupied or stressful mind misses. The post-meditative state and photographic immersion help you "see" the nuances of shapes, colors, composition, and artistic possibilities. You shift so that subject is capturing you as much as you are capturing the subject. You create and become art.

Rick has teased that he's too hyper to meditate, but when I observe him playing his guitar or immersed in teaching and bringing a creative vision to life, it's evident that he's gone to a place where his brain waves are resonating and vibrating in expanded awareness. Meditation research shows that the brain waves experienced during meditation and totally immersive experiences result in a wakeful and relaxed state. Moving to mental stillness sparks creativity and quiets the internal chatter. In this space, your consciousness shifts and you become more of an observer, which is an essential skill for life and photography.

I have come to appreciate that photography is as much of an internal process as it is a mechanical process. Being in the moment, enjoying the majesty of life and your subjects, while connecting with your camera, subjects, and fellow photographers are all therapeutic for me.

This book is designed to guide you on the internal aspects of

photography. Each chapter speaks to an element of the umbrella of mindfulness, which includes health (nutrition and exercise), healthy relationships and emotions, creative visualization, meditation, and connecting with something that brings you pure joy. These are powerful ingredients to a healthy life and an amazing photographic experience. Photo Therapy Motivation and Wisdom is just what the photographic doctor prescribes.

Linda D. Marshall
Meditation and Life Coach
lindamarshall.org

AUTHOR'S PREFACE

"If I could tell the story in words, I wouldn't need to lug around a camera."

— LEWIS HINE

After writing 39 photography, nature, children's, and travel books illustrated with thousands of pictures, this is my first book that does not include a single photograph, except for the covers. It's not that I'm tired of lugging around a camera as Lewis Hine (1874–1940), one of the greatest photographers of all time, stated; it's just that I think the message of this book is better expressed without showing my own pictures. Rather, in reading the text, I'd like you to imagine your own pictures—or potential pictures—while I am describing a situation, process, feeling, or emotion.

What's more, by showing you a photograph, I would be showing you my personal view of a subject, how I envisioned and felt about the subject. The photograph might also reveal my mood at the time I took the photograph.

And most important, the photograph would illustrate how I want *you* to see and feel about the subject. If you had been standing next to me, you might have taken a totally different picture, or for whatever reason, chosen not to photograph the subject at all. Photography is that personal and that subjective, like all art.

In addition, without knowing what went on behind the scenes, you might make an incorrect assumption about a picture. For example, I

could show you my picture of a cowgirl—with beautiful, long, flowing blond hair—on horseback, leading a herd of wild horses, all running at top speed, as they break through a cloud of backlit, billowing dust during a golden sunset.

You might say, "Rick is a pretty good horse photographer." The truth is, it was taken during one of my photo workshops. The cowgirl led the horses through the dust six times, with the goal that all the participants would get the shot. It was a set-up and well-planned shot, which included the cowgirl, horses, the light, and the background.

Keep my "horse homily" in mind the next time you see a totally amazing photograph in which only the photographer is credited. It's also an important story to keep in mind when you are comparing your photographs to those of other photographers, some of who may have had many resources, as well as several assistants.

Summing up this book in a few words: It's a combination of a Master Class, a very long TED talk, a memoir, a quick look at some famous photographers, some thoughts on curing chronic back pain (don't miss that part), and a major photo brain dump. I share important photography concepts, as well as some of the lessons I have learned in life. It's all stuff that I think will make you a better photographer and help you appreciate life, including the gift of sight, a bit more.

When a friend asked me how long it took to write this book, at first I said about three months of writing three to four hours a day. But then I realized that it actually took me almost 70 years to write, because my life today, just like your life, is shaped by experiences that happened as far back as childhood, and most psychologists agree that our personalities (which can be seen in our photographs) are formed by the time we are seven years old.

Each chapter begins with a quote that relates to the chapter's subject. You'll find more quotes throughout the book. I chose all of the quotes very carefully. I think you will find them useful in the learning process because they sum up in a few words much larger thoughts. For easy reference, you will find all of those quotes in Chapter 20.

Therapy, of any kind, involves getting in touch with—and expressing—feelings and emotions. It also involves healing, and we need inspiration and motivation to heal and to stay healthy.

Photography, be it with a $50,000 digital camera or a smartphone, is a wonderful (and these days relatively easy) way to express our inner, personal and secret ideas. It's also a way to heal a wound or fill an empty space, or to add just a bit more joy to our lives.

So although I am not a psychologist (but I have read many books by Sigmund Freud, including *Jokes and Their Relation to the Unconscious*, which I highly recommend, and have been in individual and group psychotherapy), this book is really about what goes on in one's mind when thinking about, taking, or processing a photograph.

This process is called photo psychology. From Wikipedia: "Photo psychology is a specialty within psychology dedicated to identifying and analyzing relationships between psychology and photography. Photo psychology traces several points of contact between photography and psychology. As a result, a fresh understanding of the origins of several current therapeutic and psychology testing practices based on photography emerges."

In the title of the book, I use the term Photo Therapy, two words. That's not to be confused with phototherapy, a type of medical treatment (according to verywellhealth.com) that involves exposure to fluorescent light bulbs or other sources of light like halogen lights, sunlight,

and light emitting diodes (LEDs) to treat certain medical conditions.

You will find more on light and color on the following pages.

My guess is that you are reading this book because you love photography and maybe want to understand why it's so important to you.

Perhaps you are looking for a creative outlet, which is discussed throughout this book. Or maybe you are seeking some photo inspiration and motivation, which I feel all creatives need.

You will find all that on the following pages, as well as several inspirational quotes. Here's one of my favorites by motivational speaker Zig Zigler (1926–2012) to get you started: "You don't drown by falling in water. You only drown if you stay there." In other words, if you are stuck with your photography, need a creative outlet, or want to have a greater sense of self-esteem, it's up to you to make it happen.

Speaking of making it happen, the last chapter in this book is entitled "Your Mission, Should You Choose to Accept It." In that chapter, you will find some photo therapy, inspiration, wisdom, and fun self-assignments—assignments I feel, and I hope you feel, will help you realize the impact and benefits of photography in your life. You will also find a mission at the end of each chapter.

I wish you the best of luck in your quest to become a better photographer, or as Obi-Wan Kenobi said in Star Wars, "May the force be with you."

I am no Jedi warrior, but in thinking about words of encouragement and wisdom for you, I am reminded of a 1976 Minolta camera print advertisement. The copy read: "You can take good pictures when you are the camera and the camera is you." A Zen way of looking at that expression would be: becoming one with your camera.

I'm not sure you need to be "one with your camera" to become a good

photographer, but you do need to follow what I call my "Three Ps" of photography: passion, persistence and practice.

Rick Sammon
Croton-on-Hudson, NY
September 2019

ACKNOWLEDGEMENTS

A big "thank you" goes to Susan Sammon for her support over a lifetime, as well as for her creative input on all my books.

My brother Bob Sammon gets a big "thank you" for being a great editor and friend.

My thanks also go to Linda Marshall for her words of wisdom on meditation, to Trey Ratcliff for writing the Foreword, and to Scott Bourne for writing the Introduction.

I'd also like to thank the other photographers who contributed their thoughts on the preceding pages: Jonathan Scott, Ron Clifford, Marina Barayeva, Steve Brazill, Art Wolfe, Derrick Story, Randy Hanna, Richard Bernabe, Frank Doorhof, Phyllis Webster, Alex Morley, Skip Cohen, Denise Ippolito, Gary Potts, Alec Arons, Ibarionex Perello, John Van't Land, Gary Smith, Bob Wolverton, and Rusty Parkhurst.

This book, my first self-published book, was produced by Chad and Danielle Robertson of Writing Nights (www.writingnights.org). These guys were a pleasure to work with, giving me great advice for the e-book and print version.

A final "thank you" goes to Steve Rosenbaum. In 1975, when he was the editor of *Petersen's PHOTOgraphic* magazine, Steve gave me some good advice when I showed him my portfolio, with the hope of getting published for the first time. His suggestion: "Learn how to write."

All good friends, photographers, and people!

INTRODUCTION

I am honored to write the introduction for Rick's latest book. The lessons he's teaching here, and the experiences he's sharing here, are the stuff that only a seasoned professional would know.

When we start out in photography, we focus on what camera and lens to buy. As we grow into our true artistic selves, we start to realize that the tools don't matter, the story does. Your point of view and the way that you express yourself as a photographer are how you tell the stories that matter to you. And that, my friends, is therapeutic.

There's a certain amount of Zen in that act. Peace and tranquility are hard to come by in today's world. But through photography, we all have a chance to find both.

As photographers, we sometimes lose sight of the fact that our ability to use a camera gives us a chance to show everyone else who we are. Young photographers often obsess over doing something *new*. Older photographers, like Rick and I, realize that the real goal is in being you. So focus on being you, not on being new for new's sake. This is the path to both inner and outer success.

People will ask you what you photograph. I personally am often described as a bird photographer. But we are not what we do. It's important to note the difference. And that is because people don't care what you do. They care why you do it. If you're doing what you are meant to do, you will be able to articulate your own why.

Rick travels the world, capturing and telling stories with his camera. He amplifies that with the books he writes, online classes he gives, and the talks he gives at various photo festivals and conferences. In all that activity, I have witnessed the place where Rick finds (and shares) joy. It's when he's making (or talking about) photographs. I've also worked with and around Rick long enough to know that he brings that joy to his audience every time.

I know your time spent reading this book will be very rewarding. You'll learn what should be at the heart of every image. You'll learn how to minister to yourself, and then others, with nothing but a camera.

I like to think of myself (and each of you) as a high priest of memory protection. Using our cameras, we protect the memories of our subjects; we protect the memories we have while interacting with those subjects; we help to protect the memories of our audience who sees our work. This is truly a sacred calling, and one that deserves respect and a thoughtful approach.

You have demonstrated that you are up for that thoughtful approach by reading Rick's latest book. You have a great ride in store in the following pages, and I encourage you to read them with joy and a beginner's mind. Be open-minded and take it all in. As you progress in your photographic career, you will come to know that photography really is therapy. Best wishes and know that I am rooting for you.

Scott Bourne
Picturemethods.com

PROLOGUE

T his book has no photographs, unlike my 39 other books, which include thousands of photographs. It does, however, have many more words—about 35,000.

A book on an illustrative subject is not a new idea. As my friend Steve Brazill writes: "One of my favorite books on magic is by Darwin Ortiz. It's called, *Strong Magic: Creative Showmanship for the Close-Up Magician*. There's not a single trick in the book. It's entirely on theory and audience manipulation."

My friend Jonathan Scott (The Big Cat Man) adds: "It's perfect, because it is the thought that creates the photograph. It is what you put in to it—your heart and soul and emotions. Creating images in your head is the starting point."

And fellow photographer Phyllis Webster adds: "Your concept reminds me of Stephen King's book, *On Writing*. On those pages you will not find any scary plots or characters, just how he mastered the craft of writing."

Although this book has no illustrations, I feel as though it is my most important and informative work, because I trust it will make you think—deep and hard—about your photography. After all, using your brain is the key, the best "accessory," to becoming a better photographer. Or, as famed black-and-white landscape photographer Ansel Adams (1902–1984) said, "The single most important component of a

camera is the twelve inches behind it."

As an aside, Ansel Adams was also a musician. Music is also a part—a very important part—of my life. Many of my photographer friends are musicians, too. Adams said, "The negative is comparable to the composer's score and the print to its performance. Each performance differs in subtle ways."

I agree with Mr. Adams on both points, and both of those points are discussed in this book.

If you do a search on Ansel Adams, you will find that he was just as philosophical as he was photographically technical and artistically proficient. Photography goes "Beyond the Camera," which is one of many titles that I considered for this book. "Life Lessons from Behind the Lens" was another possible title. So was "Opus 40," as this is my 40th book.

You could read this book in a few hours, but I don't suggest reading it all in one sitting. Rather, I suggest reading a chapter a day, or a week. And you don't need to read the chapters in order, as they basically stand by themselves.

If you want some quick photo and processing tech tips, advance to Chapter 20. There you will find my Sammonisms. For a more philosophical and thoughtful approach to photography, you'll find that in most of the other chapters.

Digest the ideas and then accept the missions (self-assignments) that you will find at the end of each chapter. All those missions, and a few others, are compiled into one chapter—"Your Mission, Should You Choose to Accept It"—toward the end of this book. So it's okay to skip ahead to that chapter to get a jumpstart on your photo therapy, motivation, and bits of wisdom.

On that philosophical note, on the following pages you will find, as the Beatles sang, "words of wisdom." These are some words of wisdom that I have gained by spending almost an entire lifetime, starting in the late 1950s with developing pictures in my parents' basement, involved in photography in many forms and fashions.

An important part of that wisdom has been gained by travelling to almost 100 countries around the world, as well as throughout the United States. Seeing how different people live, gaining an understanding of what is important to them, and learning about different religions and lifestyles has been an education that can't be beat. As the saying goes, travelling is the best education.

It was very satisfying, and of course therapeutic, writing this book. I hope you enjoy reading it.

P.S. Speaking of reading and writing, here is a paragraph that illustrates the power and interpretation capabilities of the human mind and the gift of sight, which I talk about throughout this book. Here goes:

Aoccdring to a rscheearch pcrojet at Cmabridge Uinervtisy, it deosn't mttaer in waht odrer the ltteers in a wrod are, the olny iprmoatnt tihng is taht the frist and lsat ltteer be in the rghit pclce.

And here's an interesting sentence that demonstrates how the mind works, as well as how and what we see: Accordion to current studies, 90 percent of you did not realize that this sentence started with the name of a musical instrument.

I include these two paragraphs to show you that in addition to being serious about teaching photography, I like to make learning fun. What's more, if you see a few typos on these pages, I hope you keep these paragraphs in mind.

More fun: There may be a selfish reason for me writing this book. They say a writer lives forever. How cool is that? Immortality! But then there is this: many of my favorite writers are dead!

1.

WHAT DOES YOUR PHOTOGRAPHY MEAN TO YOU?

"Learn from yesterday, live for today and hope for tomorrow.
The important thing is not to stop questioning."
— ALBERT EINSTEIN

A t the end of my photo workshops, and during my seminars, I often ask the participants a simple question: "What does your photography mean to you?"
I ask the question because I *know* just how important photography is to many people, and I think hearing the answer out loud helps the individual and the others in the room (or around a campfire).

Yes, it's a simple question, but one that elicits interesting—and often emotional—responses. Why the emotional response, which is sometimes accompanied by teary eyes? Because for many people, including you, photography plays an important—sometimes vital—role in life.

Below is a list of the most common responses I've heard. My guess is that you can identify with more than a few because photography truly is the universal language.

Take a look at this list. Read a comment. Stop. Consider if it applies

to you. Visualize a moment in time where you were taking a picture or processing an image where the comment hits home.

Read another comment. Stop and think. Can you relate to the comment?

An escape.

Everything.

Exploring.

Communication.

Convey ideas.

Influence others.

Feel more connected.

A way of seeing more deeply.

My social life.

Play and fun.

Reveal secrets.

A way I write my history.

Love and happiness

A happy accident.

I have no choice.

Freedom.

Owning art.

Back to my roots.

Because of it, I'm living today.

Staying fresh.

Art heals.

I have to see with new eyes every day or else I'm nothing.

I see better when I make art.

Personal evolution.

Living legacy.

Saved my life.

Allows me to be a kid again.

Making money.

In looking through this list, I find "Saved my life" the most striking.

"Allows me to be a kid again" is maybe the most fun. I have heard many variations of these thoughts.

I only heard "Making money" once, so it's truly not a reason for most photo enthusiasts to make pictures.

Of course, after everyone has shared their comments, I get asked the question, "Rick, what does your photography mean to you?"

I begin by saying that I don't have a short answer, because my photography is such an important part of my life. I go on to say that it's easier for me to talk about my camera, as in, "What does your camera mean to you?" However, my comments do, in part, answer the question.

For me, my camera is not simply a box constructed of plastic, electronics, metal, and glass—a box that is ergonomically designed and adorned with dials, buttons, switches, and an LCD monitor.

Rather, I look at my camera as a magic carpet that has transported me to about 100 countries around the world. My guess is that if I did not have a camera/magic carpet, I would have taken far fewer flights around the world. You see, I travel to take pictures and I take pictures to travel, probably like some of you who are reading this book.

My camera is also a license of sorts. It gives me permission to walk up to strangers in strange lands and photograph them (after asking permission, of course). Without a camera, I'd feel naked and awkward, with no valid reason to interact with the person. Here, too, I am sure some of you can relate to this concept.

My camera is also a time machine, capturing precious slices of time that can be relived again and again in my mind and with others. One example: a fall afternoon, when the late-afternoon sunlight was streaming through the trees in our backyard while my 10-year-old son Marco and I played wiffle ball. As my dad used to say, "I would not have missed that for the world." Today, that photograph is a precious possession. I would not trade it for a brand new Martin D35 guitar, or two. Sound familiar?

My camera, and your camera of course, can also be a "reality maker,"

2.

BECOMING AN ARTIST
AND NEVER GIVING UP

"I think everything in life is art. What you do. How you dress. The way you love someone and how you talk. Your smile and your personality. What you believe in, and all your dreams. Life is art."
— HELENA BONHAM CARTER

Do you play golf? That may sound like an offbeat question in a photography self-help book, but I ask it for a good reason. Golfers know this: taking more lessons can actually make you a worse golfer, because there are so many different "pro" techniques that can take years to master—and years to unlearn. I know that from personal experience.

Photography, I feel, is the opposite. Every little bit of advice, as small as it may be, is therapeutic and can help make you a better and more creative photographer. For example, I have a series of quick photo tips that have become known as my Sammonisms. These are all listed in Chapter 20.

When it comes to learning, what you learn in one area of photography can actually make you better in another area. For example, if you are good at flower photography, you are probably good at food

photography and insect photography because the same principles (depth of field and isolating a subject) apply. If you are good at portraiture, you are probably good at wildlife portraits, again, because the same principles apply: the eyes are in focus, you capture the subject's expression or gesture, and so on.

As we learn, we grow—photographically, personally, and maybe even spiritually. We get a wonderful feeling of satisfaction, the feeling of "I can do it!" And, if we feel as though we are creating unique and one-of-a-kind images, we can feel like artists, even if we can't draw or paint. How cool is that my friends?

But the path to becoming an artist is not always easy. Here's how I describe it to my students: Being a photo-artist is like being on a roller coaster: the highs are high and the lows are low. However, being on a roller coaster (an artist's life) is much better than being on a merry-go-ground (a 9-to-5 job).

I strongly believe that everyone can be an artist because everyone is original and everyone has creative ideas. I have seen many examples of this in my workshops, often illustrated by photographers who don't think they are artists and, maybe more important, don't know just how good they are.

Generally speaking, artists act on creative ideas more than so-called non-creative people. So photo-artists take more chances with their ideas.

Speaking of ideas, even successful artists have bad ideas. But having even not-so-great ideas is okay—unless you are perfectionist. We can still learn from these ideas, because we are flexing our brainpower.

There's a wonderful book that I recommend to my photography students called *The Artist's Way* by Julia Cameron. I recommend it to you, too, especially if you are a perfectionist. If you are a perfectionist, and even if you are not, here's a quote from the book that can help us understand perfectionism:

'We are victims of our own internalized perfectionist, a nasty internal and external critic, the Censor, who resides in our (left) brain and keeps up a constant stream of subversive remarks that are often disguised as

the truth. Make this a rule: always remember that your Censor's negative opinions are not the truth. This takes practice."

And speaking of the truth, here's a quote from my mother (originally from William Shakespeare's *Hamlet*): "To thine own self be true." As a kid, I got sick and tired of hearing that over and over. But today, I realize the importance of that idea. Thanks, Mom!

As artists, we can never give up, which is something I tell the photographers who come to me for advice.

Here's my own personal, and favorite, "never give up" story.

In the early 1990s, I had an idea for a series of 3D children's books. The concept was that a child would hold the book while wearing cardboard 3D glasses—which would make the pictures "pop" off the page—while a parent read the text. The experience would be fun for both the parent and the child.

I pitched the idea to *National Geographic*, making a five-hour drive from my home in Croton-on-Hudson, NY, to Washington, DC, where National Geographic is based. The book editor said, after spending two minutes looking at the book proposal, "Rick, this is old technology. It's been around since the 1950s. No one will be interested in this idea. Sorry."

So I drove back home, another five hours in the car, the same day. As I sat behind the wheel, I was thinking about the concept of never giving up.

Two weeks later, I pitched the concept to The Nature Company. They loved the idea! They ordered 30,000 copies each of six 3D children's books, including *Rain Forest in 3D, Under the Sea in 3D,* and *Wild Safari in 3D.* What's more, they sent my wife Susan and I to Africa, Tahiti, Bonaire, and Costa Rica—covering all expenses—to make the pictures for the books.

So when it comes to your photography and your photographic ideas, never give up. Believe in you. Also enjoy and appreciate and process, with all its ups and downs.

In closing this chapter, I'd like you to keep two things in mind: 1) smooth seas don't make a good sailor, and 2) your camera gives you a license to be creative and to do things you don't normally do.

YOUR MISSION:

Never give up.

3.

PHOTOGRAPHY CAN IMPROVE YOUR HEALTH AND SENSE OF WELL-BEING

"If you are seeking creative ideas, go out walking. Angels
whisper to a man who goes for a walk."
— RAYMOND INMON

Photography, for the most part, involves exercise—walking around a bustling city, hiking a wooded trail, hiking up a mountain path, making footprints on a sandy beach, and so on.

Those activities can help us burn calories and build muscles if we walk as if we are going somewhere, rather than just strolling along. Add a camera backpack filled with gear, a tripod, and a bottle of water, and that extra weight causes us to exercise a bit more strenuously, which can be a good thing if we want to keep in shape.

Exercising can actually change our DNA for the better, as outlined in a December 17, 2014, article "How Exercise Changes Our DNA" by Gretchen Reynolds in the *New York Times*. Toward the end of the article, we find this quote by Malene Lindholm, a graduate student at the Karolinska Institute, who led the study: "Through endurance training—a lifestyle change that is easily available for most people and

doesn't cost much money, we can induce changes that affect how we use our genes and, through that, get healthier and more functional muscles that ultimately improve our quality of life."

Another article, "Want to Be More Creative? Take a Walk," by the same author in the *New York Times* emphasizes Raymond Inmon's quote that opens this chapter. From the article: "For almost every student in the study, creativity increased substantially when they walked."

So, being a photographer can improve our physical health if we make that an added goal when we are photographing. But being a photographer can also improve our mental health, which is the main focus of this book.

Take a look at the following excerpts from an article from science-daily.com, "Daily Photography Improves Wellbeing."

A study, co-authored by Dr. Liz Brewster of Lancaster University and Dr. Andrew Cox of the University of Sheffield, recorded what photos people took, what text they added, and how they interacted with others on the photo-a-day site for two months.

They found that taking a daily photo improved well being through: self-care, community interaction, and the potential for reminiscence.

Taking a moment to be mindful and looking for something different or unusual in the day were seen as positive well-being benefits of the practice.

One study participant said: "My job was a very highly stressful role...There were some days when I'd almost not stopped to breathe, you know what I mean...And just the thought: oh wait a moment, no, I'll stop and take a photograph of this insect sitting on my computer or something. Just taking a moment is very salutary I think."

It also led to more exercise and gave a sense of purpose, competence, and achievement.

Another participant related: "It encourages me out of the house sometimes when I could just sit on my backside with a cup of tea. I'll think maybe I'll take a walk down on the seafront and before I know it I'm two miles along the coast."

I think what the aforementioned participant was saying is this: I got lost in my photography. And getting lost in a thought or an idea or an activity is a form of meditation.

So getting lost can be a good thing!

My photographer friend Richard Bernabe agrees. He writes: "Mindfulness is a state of consciousness achieved by focusing awareness on the present moment.

"For me, the very act of walking through a forest, desert, or a beach with my camera, regardless if I take a photo or not, is a form of mindfulness. I'm not ruminating on the past or worried about what I need to do tomorrow or next week.

"As I'm walking, I'm totally absorbed in the experience and my present surroundings. I'm hyper aware of shapes and light and shadows and the literal objects around me, as well as my emotional connection to all of them. I'm nurturing a state of receptiveness, so that something 'speaks' to me, and perhaps leads to a photograph. This state of mindfulness while doing photography is extremely therapeutic and clears out the mind so I feel refreshed mentally and joyful as well."

Staying focused, on everything that is around you, of course, is another good thing. Henri Cartier-Bresson (1908–2004) believed in this philosophy. He was influenced by the Zen Buddhist philosophy "one shot, one life" spirit, which talks about how achieving a goal goes beyond technique that we have to focus with our mind and heart to reach a goal.

Photography can be a rewarding process of self-expression, your own art form. I'm not talking about taking a snapshot at your Sunday barbeque, but about making creative images. Here's a bit more about how photography—and art—can help us feel better about ourselves. This is an excerpt from an article in *Psychology Today:*

> "Art therapy involves the use of creative techniques such as drawing, painting, collage, coloring, or sculpting [I am adding photography and photo processing] to help people express themselves artistically and examine the psychological and emotional undertones in their art. With the guidance of a credentialed art therapist, clients can 'decode' the nonverbal messages, symbols, and metaphors often found in these art forms, which should lead to a better understanding of their feelings and behavior so they can move on to resolve deeper issues.

> "Art therapy is founded on the belief that self-expression through artistic creation has therapeutic value for those who are healing or seeking deeper understanding of themselves and their personalities. According to the American Art Therapy Association, art therapists are trained to understand the roles that color, texture, and various art media can play in the therapeutic process and how these tools can help reveal one's thoughts, feelings, and psychological disposition. Art therapy integrates psychotherapy and some form of visual arts as a specific, stand-alone form of therapy, but it is also used in combination with other types of therapy."

I'll close this chapter with a quote from a Buddhist monk I met at the Chuang Yen Monastery in Kent, NY, which is not too far from my home in Croton-on-Hudson, NY. After asking him about the history of the monastery, I asked him, because I am interested in religions, cultures, and beliefs around the world, "What's the most important thing in Buddhism?" He took a moment, smiled, and said, "Being healthy." He went on to say, "If one is not healthy, how can one do or accomplish anything?"

Knowing that photography can improve your physical and mental health, I offer a suggestion: Make being healthy your #1 priority. I did that several years ago, which included going from three sandwiches a day to a salad for lunch, and going for two walks a day, one in the morning and one in the afternoon.

One more suggestion: take a picture every day. Before you take a picture, however, think about a caption for that picture. Ask yourself, "What does the picture say?" That process will help you determine if you are just taking a picture for a picture's sake, or trying to express yourself by capturing a mood, feeling, interesting light and color, or maybe just recording a personal and important memory.

We'll talk more about writing later on in this book.

And just an FYI: Buddhism is not a religion; it is a lifestyle. You can be Catholic, Jewish, or whatever, and still be a Buddhist.

YOUR MISSION:

Stay healthy.

GETTING IN TOUCH
WITH NATURE

*"In the end, we will conserve only what we love, we will
only love what we understand, and we will understand only
what we are taught."*
— BABA DIOUM

Being in the great outdoors has several physical and psychological benefits. In fact, according to Credit Valley Conservation (a conservation group based in Ontario, Canada), studies show that being in nature or even viewing scenes of nature reduces anger, anxiety, and stress. Spending time in nature reduces blood pressure, heart rate, muscle tension, and the production of stress hormones.

I especially like the "even viewing scenes of nature" benefit because it directly relates to photography: we view a scene in a camera's viewfinder or LCD, or on a smartphone, and then view that photograph on a computer monitor or hanging on a wall.

As a photographer who has led landscape workshops around the world, I can say with certainty that the participants immerse themselves—often lose themselves—in the ritual, if you will, of making a photograph: getting into the best position, setting up a tripod, choosing the right lens, attaching a

filter, setting the exposure, and then taking the picture. They are not think-ing about their day jobs, their investments, bills they need to pay, and so on. They are present in the moment.

So the process of going to a new location and taking a landscape photograph is a combination of photo therapy and what is called "eco therapy," which refers to the various positive physical and psychological benefits of being outside.

Speaking of those positive effects, consider this quote from realsim-ple.com. "Think about how you feel when you come home from buying something new," Thomas Vinovich, Ph.D., professor of psychology at Cornell University and co-author of a new study on gratitude, said in a paper. "You might say, 'This new couch is cool,' but you're less likely to say 'I'm so grateful' for that set of shelves."

"But when you come home from a vacation, you are likely to say, 'I feel so blessed I got to go,'" he continued. "People say positive things about the stuff they bought, but they don't usually express gratitude for it—or they don't express it as often as they do for their experiences."

Most photographers like to photograph landscapes on sunny days. That process actually has an added health benefit: the photographer soaks up more vitamin D (also known as the sunshine vitamin), which helps promote healthy bones and our immune system.

Most outdoor photographers also like to photograph sunrises, get-ting up, no matter how tired they are, at o'dark thirty to capture the beautiful predawn light as well as the sun rising over the horizon. They also like to capture sunsets, again no matter how tired they are after being out in the field all day, following the sun from the time it kisses the horizon to the time it slips slowly out of view.

Yes, seeing and experiencing a sunrise or a sunset is magical. These

moments generate feelings of peace, grandeur, healing, a new and fresh start, joy, and more—including the feeling of being special, special in that you are seeing something unique that not everyone else on the planet is seeing and photographing. You know you are capturing a special moment that will never again happen exactly the same way.

And who does not want to feel special? In fact, some psychologists feel that we all need to feel special.

Being in a special place and making a special picture, even if it's only special to you, surely gives us that special feeling. It's a feeling of "I did it," or "I'm good at something," or "Others will like my art, and what I have to say with my photographs," or even "Others will like and respect me for what I have accomplished."

Now I know this is going to sound "far out," as we used to say in the 1960s, but your photography is, to a degree, about the space-time continuum. The space-time continuum is a mathematical model that combines space and time into a single idea.

You see, when you take a picture, you convey a feeling with time (the exact moment you take a picture) and space (your unique and special composition). If we were standing next to each other, we would take similar, but not exactly the same, photographs.

Far out? Sure, but also "groovy," which was another term popular in the 1960s.

More on timing: For photographers, a sunrise or sunset is all about timing—and time. We know we have a relatively short time to capture the beauty of one of Mother Nature's masterpieces. So time is on our mind. Thinking about how fast time goes by is also an escape from our normal reality that gives us an appreciation for how fast time passes, which, I think, gives us a better appreciation for life, which in turn can make us better people. Again, photo therapy at work.

Speaking of thinking about time, the opposite—not thinking or worrying about time—can be good, too. I'll talk about that later in these pages.

I'll end this chapter with an excerpt from an email my friend Art Wolfe sent me when we were talking about this book, and about protecting the environment. For those of you who don't know Art Wolfe, he is one of the most respected wildlife photographers on the planet.

> "I have been photographing wildlife since the beginning of my professional career. Long before that, however, I was a naturalist as early as I can remember. I was the kid playing in the woods, spying on bird nests, collecting insects, and so on. For me, the life I have lived has been enriched and nourished by the wildlife I have witnessed, photographed, and ultimately shared though my pictures with others. It is clear to me that for every species lost, the world becomes a little less interesting, a little less healthy."
>
> Art Wolfe
> Artwolfe.com

YOUR MISSION:

Consider how the space-time continuum relates to your photography.

5.

EXPERIENCING THE CIRCLE OF LIFE

"Everything you see exists together in a delicate balance. As king, you need to understand that balance and respect all the creatures, from the crawling ant to the leaping antelope."
— MUFASA, DISNEY'S *LION KING*

Many photo experiences can change our lives, but perhaps none as much as seeing and experiencing the circle of life on an African safari.

Yes, seeing the life drain out of a newborn baby zebra as it is being eaten alive by a hungry lion, while the mother zebra looks on, can bring a tear to your eye, as it did mine on one safari. But on the other hand, you smile when you see healthy lion cubs, having dined on a baby zebra meal provided by their parents, playing with each other like cute little kittens.

And when you see a giraffe giving birth, as the newborn drops to the ground and the baby stands up relatively quickly—within about 30 minutes—you are overjoyed that you experienced one of the wonders of Mother Nature.

Watching animals hunt in groups, communicating in ways that are still not fully understood by scientists, is also an experience filled with wonderment and awe.

Capturing those moments with your camera can be a form of photo therapy, because you can relive them again and again. You can share those moments with family and friends, and sharing provides a good and positive feeling. You can also share your photographs online, helping to show others the wonders of nature, which is educational. So in sharing, you can also be an educator, which is another positive feeling, as any teacher or professor will tell you.

There are many ways to go on an African safari, for the budget-minded and millionaire alike. If you are seeking some photo therapy, an experience during which you can forget about the wild and crazy world in which we live and work, I recommend getting to Africa to see, experience and capture the circle of life.

On-site, you will be in the moment (like in a meditation) of the action.

And if you go, I promise you, you will not come back unchanged. Looking back on your memories will be good photo therapy.

YOUR MISSION:

If you can't go on an African photo safari, visit a zoo or wildlife park and enjoy making pictures.

6.

CREATING
YOUR OWN REALITY

"Reality leaves a lot to the imagination."
— JOHN LENNON

I have a presentation (as well as a book) called *Creative Visualization for Photographers*. The idea of the presentation is that we need to visualize the end result before we take a picture. We need to envision how a three-dimensional scene will look as a two-dimensional image, how light will be captured by our cameras, which is different than how our eyes see light—highlights and shadows. We also need to think about capturing the colors in a scene.

We need to think about what we want to include in the frame by subtracting elements in the scene, either by careful composition or by cropping in the digital darkroom. That process, by the way, is the opposite of what an artist does when creating a painting: a painter adds elements to a canvas. Therefore, photography is a subtractive process, while painting is an additive process.

Speaking of being subtractive, think about this for a while: a photograph hides more than it reveals. For example, a photograph can hide what we don't want to see in a scene, and reveal only what we want to see in a

scene. After spending a lifetime behind the lens, I can say that is true.

Getting back to creative visualization, we need to think about creating a mood or feeling, which, as with a pop song or classical musical score, is paramount.

Part of conveying a feeling is creating a feeling in ourselves. Rolling Stones' guitarist Keith Richards agrees. "I don't think, I feel," he said about playing guitar onstage in *Shine a Light*, the Martin Scorsese film about the Rolling Stones' 2006 performance at the Beacon Theatre in New York City.

Carlos Santana, my favorite electric guitar player (who I saw perform at Woodstock in 1969), thinks feeling is important in music, too. In his online Master Class, he shares a story, paraphrased here, about music during the hippie movement/San Francisco sound of the early 1960s. He says that before his band arrived, the girls would dance at outdoor concerts as if they were trying to catch butterflies. But when Santana played with feeling, the girls would dance like they were saying, "I'm filled with energy and excitement, come and get me."

I experienced this at Woodstock. Since then, I have not heard many guitar players who play with as much feeling as Santana.

As photographers, we need to "feel it," too. We need to be in the moment and feel the energy or peace of the subject—be it a person or a landscape or an animal—in order to create our own reality.

I used to teach piano, specializing in jazz improvisation. Many photographers, including Ansel Adams and Gordon Parks, were also musicians.

Many musicians, including Graham Nash, are also avid photographers. My friend Scott Kelby is equally good behind a camera as he is playing a guitar.

On the topic of feeling, I'd like to share with you a conversation I had with one of my first-time piano students, who actually had something in common with my photo workshop students. I think it illustrates the importance of feeling, in music and in photography.

Student: "Rick, do you think I should use a blues scale for my solo, or do you think maybe playing in fourths [a very open sound with notes four notes apart from each other] would be better?"

Me: "It does not matter what notes you play. It matters how you play them."

Student: "Uh, that really helps me a lot, Rick. Okay, do you think my solo would sound better on a Hammond B-3 organ, a Fender Rhodes electric piano, or a Yamaha grand?"

Me: "Well, I like the sound of the organ, and the piano, and the synthesizer and the grand piano. But have you ever considered the accordion? Rock musician Billy Joel uses it, and so did jazz musician Toots Thielemans."

Getting a bit agitated at this point, the student said, "Fine, you are a big $#%! help. I'm not taking lessons from someone who can't teach me anything. I'm out of here."

Smiling, hoping I can keep the student, who I really want to help because I truly enjoy teaching, I said, "Before you go, I'd like to give you some free advice, if I may."

Student: "What's that, maestro?"

Me: "Don't think so technical, although technique is important. When you play, play with feeling. Play with passion. Above all, play for yourself. Think about your inner feelings."

The student, who really wanted to learn and was actually quite talented, was quiet for a moment, and then his eyes filled up with tears. (I have seen this on photo workshops when a photographer realizes how important photography is to him or her, as I outlined in Chapter 1). Yes, I kept the student, who learned that feeling was more important than technique. And I find that repeat photo workshop participants are also more interested in the feeling a photograph than in, for example, the exposure triangle (ISO, aperture, and shutter speed).

One of my former photo workshop students, Chandler Strange, says, "In regard to evoking a feeling in a picture, that's all we talked about all

day in photography school."

Many of my professional photographer friends share my feeling about photography. It's evident in their work.

Lou Jones: The pictures in his book on death row inmates, *Final Exposure,* convey the feeling of his subjects, and the feeling he had when he took the pictures. (I actually met Lou while attending Berklee College of Music in Boston in 1973.) Your first thought when looking at Lou's work isn't, "Wow! Lou must use a really sharp lens."

Chris Rainier: Look at this master's pictures of the people of New Guinea and I don't think you'll ask yourself, "What f-stop did Chris use?"

Darrell Gulin: Look in the eyes of the animals in his wildlife pictures and you'll see that Darrell has an intense passion for wildlife photography, as well as sensitivity for his subjects.

Joe Farace: This digital artist likes to convey feelings in pictures after the fact in the digital darkroom. I saw this immediately when Joe showed me a picture he took in Tulum, Mexico. Joe turned a dull, daytime shot into a beautiful picture—a romantic picture—that looks like it was taken at night.

Steve McCurry: Take a look at the picture of the woman on the cover of his book, *Portraits.* Look at the woman's haunting eyes. What feeling do you get?

John Paul Caponigro: John Paul's images are pure fantasy, created somewhere within this artist's mind's eye and brought to paper through the magic of the digital darkroom. Everyone looking at his images will get a different feeling, but no one will come away without some sort of feeling or impression.

I could go on and on.

For people who know me and know that I love to photograph strangers in strange lands, a natural question at this point would be, "So, Rick, do all your people pictures convey a feeling?"

I hope so, is my answer. They create a very special feeling for me because I follow the same advice I gave my former piano student. I shoot with feeling. I shoot with passion. I show respect. Above all, I shoot for myself.

Here are some final notes in this homily. When looking through your camera's viewfinder, remember these two expressions: "Camera's don't take pictures, people do." Just like, "Pianos don't make music, people do."

Getting back to my Creative Visualization for Photographers presentation, I say that I could have called it Photography and the Death of Reality, because by simply cropping out elements in a scene, we are creating our own reality. For example, I may have a dramatic portrait of a leopard, but without the surrounding area, you may not know if I took the photograph in a zoo or on an exotic safari.

Taking the color out of a scene, combined with careful cropping and exquisite image processing, is another technique for creating one's own photographic reality. Here's a story to illustrate that point. Well before e-mail, famed landscape photographer Ansel Adams (1902–1984) received a letter (paraphrased here) from an unhappy fan:

Dear Mr. Adams, I'm a bit unhappy with you. I have your books and some of your posters. I have loved your work for many years. You inspired me to go to Yosemite, and when I got there, it did not look like that.

Recounting the idea of this letter, shared with me by John Sexton, one of Ansel Adams' assistants, in my presentations brings a laugh from the audience s. But after the laughs subside, the message rings true: Ansel Adams, through masterful images, created his own reality. And so can you!

I go on to say that I also could have called my *Creative Visualization* book, *Photography and the Birth of Creativity*, because thanks to the ease of applying digital enhancements—on our computers and with apps on our smartphones—photographers can be more creative than ever.

One of the messages of this chapter is that we can create our own reality with our cameras and computers. What could be more fun for a photographer? What easier way to escape from reality—maybe a not-so-favorite 9-to-5 job or, at the other end of the spectrum, the loss of a loved one.

Toward the end of my *Creative Visualization* talk I mention Dr. Wayne Dyer's book, *Real Magic: Creating Miracles in Everyday Life*, which I mention in Chapter 1 of this book. Again, Dr. Dyer talks about how we can create our own reality. I share that philosophy with the audience because some audience members would like to be full-time travel photographers, traveling and experiencing the world.

I also mention Pam Grout's best-selling book, *E²: Nine Do-It-Yourself Energy Experiments that Prove Your Thoughts Create Your Reality*.

Of course, some things in life are beyond our control, such as a mass layoff when an automotive plant is shut down due to poor car sales, or when the downsizing of a company results in a job loss. That being said, there might have been clues to those situations looming on the horizon, which could have resulted in an individual taking action or working on a backup plan.

So, my friends, the other and more important message of this chapter is that we can, to a degree, create our own reality, living the life we want to live by starting to live that life. Here's a short story that will help you make sense out of that statement.

In 1980, at age 30, I took a job heading up the Minolta public relations

account (as Vice President and Group Supervisor, if you can believe that) at a major Madison Avenue advertising agency, Bozell & Jacobs. Suit, tie, vest, and shined shoes. I took the job for one reason: the salary.

At the time, photography was not a passion; it was just something I did for fun.

Shortly after starting the job, I realized I was unhappy. Money was not everything.

As part of my job, I met several high-profile professional photographers who, to me, lived a dream life. Rather than sitting behind a desk, I dreamed of living their life.

After a few years, while keeping my 9-to-5 job, I decided that I wanted to be a professional travel photographer. I bought some cameras and a photo vest and, with my wife Susan, started to take vacations to places that included Tahiti, Fiji, Indonesia, and so on. We traveled the world, and when I got home, under different names (Richard Michaels and Richard Trout), I wrote photo magazine articles and a few how-to books.

Then, under our own names, while still at the agency, Susan and I wrote our first real picture book, *How to Photograph Water Sports and Activities*.

On my own time, I was living the life I wanted to live. I was creating my own reality.

Well, my boss realized what was going on and at age 40, after 10 years at the agency, he fired me—not unexpectedly and not unwanted. It was something that I had planned for years by saving as much money as possible as a cushion in case things did not work out.

But things did work out, and here I am, living the life I want to live. I say in my presentations, "If it worked for me, it can work for you." I go on to say that one must make a careful life plan to create your own reality, and one must be willing to go through the ups and downs of changing one's life.

If I make all this sound easy, it was not. In fact, to be totally honest, it was extremely painful, physically and emotionally. Let me explain in a very short version of a very long story. It is a story that has helped

dozens (88 at last count) of people that I personally know.

My feeling of anger and frustration at myself for "selling out" and not doing what I really wanted to do—being me—caused me crippling back pain shortly after starting the job. After going to several doctors, I met one doctor in 1982 who said I needed back surgery for a herniated disk. I had the operation and was cured—for a few months. The exact same pain returned in the same spot.

I put up with the pain for a few more years and then, while I was lying in a hospital bed waiting for a second back operation, a friend, Harold Center, called and told me to get the hell out of the hospital and go see Dr. John E. Sarno, who was a professor of rehabilitation medicine at the New York University School of Medicine.

Long story short, I took my friend's advice and saw Dr. Sarno. While lying on the floor of his office, because the pain was so bad I could not sit, he smiled and said to me, "You've come to the right place."

Well, I followed Dr. Sarno's advice and was totally cured without needing another surgery. I could go on, actually filling this book with Dr. Sarno's philosophy, which is actually based on psychotherapy. Rather, I suggest you watch his YouTube videos and read his books, including *The Mindbody Prescription and The Divided Mind.*

I also suggest picking up a copy of *Pathways to Pain Relief,* co-authored by Dr. Eric Sherman, who I met through Dr. Sarno and who is carrying on his work. You can also consult with Dr. Sherman in his New York City office.

Following Dr. Sarno's advice helped me create my own reality and even saved my life. Yes, the pain was that bad.

Today, I still have that herniated disk, plus one more (as seen on an MRI). In addition, I have some scar tissue from the operation. Yet I am totally pain-free. Dr. Sarno explained that, in most cases, herniated disks do not cause the pain. He also explained that an operation is a great–maybe the best–placebo.

I'll end this chapter with a few inspirational and motivational quotes on creating your own realty. Rather than stringing them together and reading them fast, read each quote slowly. Think about the message. Carefully. Then go on to the next quote.

"Photography is a kind of virtual reality."
— STEVEN PINKER

"Few people have the imagination for reality."
— JOHANN WOLFGANG VON GOETHE

"In my opinion, there is no aspect of reality beyond the reach of the human mind."
— STEPHEN HAWKING

"We don't create a fantasy world to escape reality. We create it to be able to stay."
— LYNDA BARR

"What you dwell upon you become."
— BUDDHA

"It is done unto you as you believe."
— JESUS

"Whatever a person's mind dwells on intensely and with firm resolve, that is exactly what he becomes."
— HINDU EXPRESSION

"We do not see things as they are, we see them as we are."
— AS WRITTEN IN THE TALMUD

"We become what we think about all day long."
— RALPH WALDO EMERSON

"If you can dream it you can do it."
— WALT DISNEY

"Change your thoughts and you change your world."
— NORMAN VINCENT PEALE

"You see it when you believe it."
— DR. WAYNE DYER

YOUR MISSION:

Always keep in mind that you are constantly creating your own reality

7.

LOOKING VS. SEEING

"A photograph is usually looked at—and seldom looked into."
— ANSEL ADAMS

Yes, this book is about photography, but I'd like to share some thoughts here on being a musician before I get to the difference between seeing and looking. Please bear with me. This will all make good sense.

For musicians, there is a big difference between hearing and listening. For example, if a musician is driving around in a car with the radio on while having a serious conservation with a friend, he may not be listening to all the subtleties of a song—how the bass is complementing the drums, how the singer is phrasing the words, how a soloist is leaving space between the notes and so on. He is just hearing.

On the other hand, if a musician is driving around alone with the radio on, and is interested in a song, he is listening and not simply hearing. Most important, there is joy in listening because he appreciates the arrangement, skill of the musicians, and production of the song.

The analogy to photography is simple: there is a big difference

between looking and seeing.

A non-photographer sees a scene, but may not appreciate all the subtle details, especially in the shadow and highlight areas. And a non-photographer may see a portrait, perhaps one by Yousuf Karsh (1908–2002), and not appreciate the hours and hours of work that went into the lighting and processing of the photograph.

A photographer, on the other hand, looks at all the details in the scene, and appreciates how our eyes and our cameras capture shadows and highlights, contrast, colors, and details. The photographer would also appreciate, maybe even marvel at, the Karsh of Ottawa (as he was also known) black-and-white portrait of Ernest Hemmingway, which seems to glow from within.

The photographer also looks for creative composition. That act of striving for creative and unique composition is one of the keys to becoming a good photographer, which of course gives us a feeling of well being.

I'd like to share two more thoughts on photographic composition that apply to photo therapy, and of course, your photography.

ONE: I have what I call my "One-Picture Promise." When you are in a situation, imagine you only have one frame remaining on your memory card, and you can take only one picture. If you think like this, I make you this promise: You will have a more creative photograph. What's more, during a photo outing, you will have a higher percentage of creative photographs and fewer outtakes.

I can tell you from experience this idea works, because the photographer slows downs and thinks—really thinks—before taking a picture. It's kind of like what I talk about in Chapter 3: Photography Can Improve Your Health and Sense of Well-being. In that chapter, I talk about the Zen Buddhist "one shot, one life" spirit, which is about how achieving a goal goes beyond technique and about how we have to focus with our minds and hearts to reach a goal.

The opposite of my "One-Picture Promise" is OCD. I am not talking

about Obsessive Compulsive Disorder, which is a syndrome that makes a person feel driven toward a certain obsession or fear. Rather, I am talking (with tongue in cheek) about Obsessive Clicking Disorder, which I first witnessed on an African photo safari.

When two of the photographers on the safari saw anything even remotely interesting, they clicked away, sometimes taking up to 700 pictures of a subject. One time, the subject was a pack of wild dogs that were sleeping in the shade. The incessant clicking almost dove me nuts!

At the end of the safari, one photographer said, "I filled 24 132GB cards." The other photographer said, "I took 24,000 pictures." On that safari, I found that the photographers who followed my "One-Picture Promise" went home with more creative images, not to mention having much more time to work on those important images in Photoshop and Lightroom. But, as my Dad used to say, "To each his own." FYI: I took maybe 3,000 pictures on that trip.

While I am on the subject of OCD, there is another type of OCD that I do actually have: Obsessive Cropping Disorder. The first thing I think about when I open a file is this: How can I crop the image to make it more interesting, or to give the image more impact?

Some of my professional photographer friends are totally against cropping. They say you must get it right in-camera. However, to those photographers, I say with a smile, "By simply using a telephoto lens, you are cropping out some of the reality from a scene."

When it comes to cropping, one philosophy to keep in mind is that cropping gives us a second chance at composition.

Enough obsessing over OCD. Let's get to number two.

TWO: So far, in this chapter, we have talked about music, photography, and Zen. Now I'd like to share a thought about golf with you, which also applies to photography and photo therapy.

I have taken a lot of golf lessons in my life. The best tip I ever received, after the pro saw me take a swing, was: slow down.

That simple tip greatly improved my game.

I give the same tip to my photo workshop students: slow down. Think before you shoot. Enjoy and explore and experience the moment. Think about the "one shot, one life" spirit.

Whether we are talking about seeing or looking, it's important to consider the wonder of the human eye, especially when it comes to how it compares to a camera's digital image sensor. Stopping to think about the amazing light-capturing capabilities of the eye can be good photo therapy, because it gives us a true appreciation for the magical gift of sight and what we as photographers can do with it.

In researching the light-capturing capabilities of the human eye I came across an article, "What's the Difference Between a Camera and a Human Eye," by Haje Jan Kamps on the following website: medium.com/ photographysecrets.

Here are some quotes that I found quite interesting.

"In sunlight, objects receive 1,000,000,000 times more light than on a moonless night—and yet, we are able to see under both circumstances."

"In bright daylight, we can see further than in twilight. Here's why. Imagine you have a camera that's focused on 1 meter. In bright daylight, you may be able to use f/16 aperture, which means that you can see beyond 1 meter (due to the increased depth of field). In lower light, you have to use a larger aperture (say, f/2.8), which gives you a lower depth of field, and you may only be able to photograph things that are 1 meter away. In bright light, your eyes contract (you get tiny little pupils), and in low light, the opposite happens. Just like when you're taking photos! What's more, studies have shown that our eyes are around 600 times more sensitive at night than during the day."

In his insightful article, Haje Jan Kamps also talks about the importance of the retina in the human eye, which acts like the image sensor in a digital camera.

I have a personal story on the importance of the retina, and why we must protect it.

When my dad, Robert M. Sammon, Sr., was about 80, he started to develop macular degeneration, which is the leading cause of blindness in people over 60 (but has been detected in people in their 40s.) It occurs when the small central portion of the retina, known as the macula, deteriorates.

With my dad, an avid amateur photographer, it started as a small dark and blurry spot in the center of his vision. Over the years, the dark and blurry spot increased in size. When he was in his late 80s, he could only see the expression on my face if he looked away from me, because I was then positioned in his peripheral vision. When working on his computer monitor, he had to look away from the screen and use a 72-point-size font. He could only see a few words at a time.

Over those years, I took him to the eye doctor for treatment, which included injections directly into the eye. No fun for either of us, especially him.

Treatments for macular degeneration, including drugs and lasers, have improved since then.

The message here is that we need to protect our eyes. Wearing a hat and sunglasses—two things my dad never did when he soaked up the sun in a lounge chair in our backyard on weekends—helps to protect our eyes from damaging ultraviolet light.

Staying healthy is important, too, as causes of macular degeneration also include heredity, hypertension, sedentary lifestyle, and obesity. Recent research shows that poor diet and nutrition may also be a cause of macular degeneration.

I watch my diet and try to eat healthy. But according to my eye doctor, taking a daily supplement such as Lutein, which is found in

supplements like Ocuvite®, can also help in keeping our eyes healthy. In fact, he told me, "You're nuts if you don't use it."

While discussing my photography, my eye doctor asked me if I photographed sunrises and sunsets. "Of course," I said. He then went on to explain that looking too long at the sun (or other bright lights, like a welder's torch) causes solar retinitis, also known as solar retinopathy—a condition in which the retina is damaged due to a photochemical injury, as opposed to a burn. The result is a yellow spot in one's vision.

Unlike macular degeneration, solar retinitis is *typically* reversible, but it may take days, months, or years for someone to regain full sight.

When photographing a sunrise or sunset, the best way to avoid eye damage is to avoid using your camera's optical viewfinder. Rather, use Live View and view the scene on your camera's LCD screen or in the electronic viewfinder.

By now you realize, from a technical standpoint, how much I value, as well as wonder, at our eyesight. If you are interested in learning more about the technical side of eyesight and—get this—how it relates to art (our photography), check out *Vision and Art: The Biology of Seeing* by Harvard neurobiologist Margaret Livingstone.

The entire book is fascinating, but here are my favorite chapters:

- Chapter 2: The Eye and the Brain
- Chapter 7: Acuity and Spatial Resolution
- Chapter 9: Where vs. What
- Chapter 10: Special Effects of Equiluminant Colors and Illusion of Motion
- Chapter 15: Faces

Hey, if you are not familiar with the term "equiluminant colors," neither was I until I read *Vision and Art*. Basically, the term refers to how the use of color and brightness, factors we can easily control in

Photoshop and Lightroom, can add a sense of motion to a still image, making a sunset sparkle and a flower shimmer.

Here is another interesting point that Ms. Livingstone discusses: in Leonardo da Vinci's *Mona Lisa* painting, the subject's expression changes depending on what part of the painting you are viewing. Here, too, this sort of insight can help us with our photography, especially when it comes to portraits.

For serious photographers like you, I also recommend reading *Color and Light: A Guide for the Realist Painter* by James Gurney (creator of Dinotopia). Yes, it's another non-photography book, but it's a book that will help you better understand the importance of light and color in your photography.

Here are some quotes (chapter openers) from Mr. Gurney's fascinating book:

"Moonlight isn't really blue. It's actually slightly reddish. It just looks blue because our visual system plays tricks on us when we look at things in very dim light."

"There can be as many as 20,000 leaves on a tree. If you try to capture all that sharp detail, you might miss the sense of softness, delicacy, and interpenetration with the sky. The key is to be aware of sky holes and transparency."

And here is a quote that I especially like, which is explained in detail in the chapter: "Although photographs are useful reference tools in many ways, they often are disappointing when it comes to recording color. In your plein-air studies, you can observe and record nuances of color that completely elude the camera."

Two FYIs about the previous quote:

"Plein-air" is a term first used by French Impressionist painters to describe painting outdoors—painting in plain air, as opposed to painting in the studio.

2) By using a device in the field called the Passport Color Checker (not invented at the time Mr. Gurney wrote his wonderful book), and

then using the associated software, it is quite possible to get accurate color on your computer monitor, if your monitor is calibrated. To get color-accurate prints on your inkjet printer, you also need to calibrate your printer and use the correct color profile.

Here is a visual exercise that illustrates the difference between seeing and looking. You can try it the next time you see a double rainbow.

At first glance, the rainbows may appear to be similar, with the second, outer rainbow being a bit dimmer than the main rainbow. But if you look closely, you will see that the colors in the second rainbow are inverted, with blue on the outside and red on the inside. A Google search on double rainbows illustrates this point.

As an aside, in some Eastern cultures, a double rainbow is considered a sign of good fortune. The first rainbow represents the material world and the second rainbow represents the spiritual world.

Speaking of exercises, here is one developed by photographer/photo educator Minor White (1908–1976).

Mr. White would take his students to a rocky area, high above and overlooking the Pacific Ocean, in Shore Acres State Park on the Oregon Coast. The area, introduced to me by my friend Alex Morley, is about the size of a football field. It features a long and wide, fairly level ledge that you can walk on (hiking boots are recommended). There is also a long wall, about 12 or 15 feet high, that you can walk along.

Alex and I have conducted several workshops here, and I can tell you that it's like being on the moon. The seemingly endless number of soft-

looking, but rock-hard shapes on the ledge, carved out of the stone by the wind and water, and the intricate patterns created along the wall, are out of this world.

Minor White would take his students here to learn about composition, to help them develop what he called "pristine vision." In other words, he would make the suggestion: Don't photograph shapes and forms you recognize.

Again, having been to this area, which is now known to photographers as "Minor White's Wall," using pristine vision is not an easy assignment. In fact, when I lead a photo workshop here, I suggest this exercise: look for and photograph what you recognize. The result? My students have photographs in which you can easily recognize a lion, a heart, a wave, an eye, a bird, a monkey, faces, and more.

They get zoomorphic images, where it's easy to see an animal in the frame; anthropomorphic images, where a man's face is the focus of the photograph; isomorphic images, where a shape can't be mistaken for a common object, such as an ice cream cone; and theomorphic images, where a beast or a wild animal is easily recognizable.

After my students have completed that assignment, I suggest the "pristine vision" assignment. The result: wonderful images of shapes and patterns, and images where light and shadows are the main subject.

With all this in mind, when you are looking for pictures, look for what you recognize, as well as what you don't.

YOUR MISSION:

Think about my one-picture promise.

8.

LEARNING IS HEALTH

"Learning is health."
— BUDDHIST PROVERB

Learning a new skill like photography, or learning how to im-
prove a current skill, has many benefits. Looking inward, learn-
ing adds some fun and satisfaction to our lives. It can also fight
off boredom and improve memory. Looking outward, learning can make
us a more interesting and fun person, because we have more to share.

And get this about learning, according to an article on the CCSU
(Central Connecticut State University) website: "The white matter in
your brain is called myelin, and it helps improve performance on a
number of tasks. The more people practice a new skill, the denser the
myelin in their brains becomes, which helps them learn even better."

With all this in mind, if you are serious about your craft or hobby, it
makes sense that the more you take pictures, the better you will get and
the faster you will become a good photographer, and that can lead to
being a happier and healthier person.

I had a different title for this chapter: Zen and the Art of Photography. In the Zen philosophy, the goal is to enjoy the process and not be so focused on reaching a set goal. Robert Pirsig illustrates this idea in his book, *Zen and the Art of Motorcycle Maintenance.* In the book, a father and son are driving across the United States on a motorcycle. The father is enjoying the experience (Zen) while all the son wants to do is get to the destination.

When learning photography, I think it's important to apply the Zen philosophy: enjoy the process.

A model developed by Noël Burch in the 1970s can help us understand the process of learning new photography skills. The "Four Stages of Learning" are familiar to most educators. They are:

- Stage 1: Unconscious Incompetence.
- Stage 2: Conscious Incompetence.
- Stage 3: Conscious Competence.
- Stage 4: Unconscious Competence.

Let's explore these stages as a form of photo therapy, which includes enjoying the process of learning.

Unconscious Incompetence: We pick up a camera, take some pictures and don't know about all the photo challenges that lie ahead, because we don't really know if we are good or bad, or have or don't have natural talent. We continue the learning process.

Conscious Incompetence: Ah! At this stage we are starting to feel good about the learning process. As we learn a few new techniques, we start to feel better about our photography and ourselves. We know we can do it, but we know there is a lot to learn. This stage has its ups and

downs, as do most things in life. But as with most things in life, if we set a goal and don't give up, that goal is attainable. For photographers, that means taking more and more pictures and learning from our success and failures.

As Henry Ford said, "Whether you think you can, or you think you can't—you're right."

And as the Beatles' George Harrison wrote: "With every mistake, we must surely be learning…"

Conscious Competence: Simply put, at this stage, you know you are good. Your hard work, dedication, and perseverance have paid off. Your self-photo-therapy sessions are not over, because learning is a lifelong process, and because we can actually go back and forth between stages as we learn more. As the expression goes: The more I learn, the less I know.

Unconscious Competence: At this stage, you just do it, as stated in a Nike ad. As a photographer, you don't need to think about your shutter speed, aperture, ISO setting, and so on, when taking a picture. All this comes automatically, which is very cool.

It's the same for accomplished rock or jazz guitarists. When they are playing an improvised solo, they are not thinking about what key they are in, how they are bending the notes, how they are adjusting the knobs on the guitar, applying vibrato, and so on. They are—that's right—just doing it.

One more thing on the learning process: How do we learn all the things about our cameras and image processing to get to the Unconscious Competence level? Well, author Anne Lamott has a suggestion in her wonderful book, *Bird by Bird: Some Instructions on Writing and Life*.

To condense a story in the book, well before computers, Ms. Lamott and her brother were sitting at their kitchen table. Her brother was working on a report on birds as their dad looked on. Her brother was somewhat overwhelmed at all he had to learn about birds for the report. He looked to his dad, "Dad, how am I ever going to learn all this stuff?"

His dad smiled and said, "It's easy son, just do it bird by bird."

The lesson here is to learn photography little by little. Don't put pressure on yourself to know everything about composition, exposure, lighting, and image processing all at once. And most important, don't try to be someone else, maybe trying to be as famous as another photographer. This can have a negative effect, especially for those who spend their whole lives trying to be someone else.

My friend Phyllis Webster writes: "As someone who is still a developing photographer, I identify with the four levels of learning so well! I did not know how bad I was, which was terrible because I was educated and trained in the era of black-and-white film, worked in the wet darkroom, etc. I always recognized and knew that I was not producing the work that I admired from others, and I did not know what I needed to do to improve.

"About ten years ago, my passion for photography was reignited in a way that was much more focused on learning about the craft and pushing myself to be better. Finally switching to digital forced me to learn my camera again!

"The result? I take workshops, listen to podcasts, take online classes, read books by photographers, and follow photographers whom I admire on social media. I take photos more often. And I know that I will never stop learning."

YOUR MISSION:

Follow your heart and enjoy the process. Always.

9.

PHOTO THERAPY AND SOCIAL MEDIA

"Stay away from negative people.
They have a problem for every solution."
— ALBERT EINSTEIN

I've got good news and bad news for you about social media. As a positive person who is writing a book on how photo therapy, which includes sharing your work, can help you, I first thought I should start with the good news. However, I think the bad news about social media might be more important to understand, so I'll start with that. I'll end with the good news.

At first, posting pictures on social media sites like Facebook, Twitter, Instagram, and so on, can be, as one might think, a kind of photo therapy. You post a photo and get some likes and comments, and you feel a certain sense of satisfaction. That's good!

But all too often, one's immersion in (and addiction to) social media can have a negative effect. I have seen this among some of my friends. It's more important for some to have a million followers, which they flaunt, than it is to make a meaningful image.

Check this out: Leeds University found a potential link between

internet use and depression: "Our research indicates that excessive internet use is associated with depression, but what we don't know is which comes first—are depressed people drawn to the internet or does the internet cause depression? This study reinforces the public speculation that over-engaging in websites that serve to replace normal social function might be linked to psychological disorders like depression and addiction."

There is more: for a lot of people, visiting sites like Facebook can actually result in a negative mood shift. For one reason, as you see the highlights of other people's lives, you may feel envious, and too much envy can lead to depression.

People have suspected this for quite some time, but in 2015, a study by the University of Missouri confirmed it. If Facebook is used to see how well an acquaintance is doing financially or how happy an old friend is in his or her relationship—things that cause envy among users—use of the site can lead to feelings of depression.

So what about the good news? Well, social media can help us socially, helping us to connect and make new "friends." I put "friends" in quotes because I have 5,000 "friends" on Facebook, most of whom I have never met or spoken with.

Some more good news is that social media can actually help people with depression (some of whom many need photo therapy) and help to save lives, as illustrated by many suicide prevention sites. All this is good. Very good.

When you post a photo on a social site, you may get positive feedback and learn from what others may say. They may see something in a photograph that you did not notice or see. You get free advice. You may even get a photo sale or job. That's all good news.

For more on social media, check out my friend Trey Ratcliff's book, *Under the Influence: How to Fake Your Way into Getting Rich on Instagram: Influencer Fraud, Selfies, Anxiety, Ego, & Mass Delusional Behavior*. It's a must read for photographers on social media.

10.

GROUP PHOTO THERAPY

"The path to greatness is along with others."
— BALTASAR GRACIÁN

L et me ask you a question: How many times have you gotten up in the dark, driven to a sunrise location in the dark, set up your gear, and waited for a sunrise...by yourself?

My guess is not that often, because although you might want to see and photograph a sunrise, you don't *necessarily* need to make the effort. It's easier to sleep in, especially when it's cold outside.

When you are with a group of photographers on a photo workshop, however, you are much more likely to get out of bed, have bad hotel coffee, and head off to a sunrise location, because you don't want to let the group down or because you don't want to miss anything...including maybe getting "the best sunrise photo ever taken" in that location. It could happen.

It's the group that helps drive the individual photographer. But there's more to being in a group. Working and playing with other photographers can be like going to group psychotherapy, with similar benefits.

In an article on Psychcentral.com, Margarita Tartakovsky, M.S., an associate editor at the site, lists the following benefits of group psychology:

- Group therapy helps you realize you're not alone.
- Group therapy facilitates giving and receiving support.
- Group therapy helps you find your "voice."
- Group therapy helps you relate to others (and yourself) in healthier ways.
- Group therapy provides a safety net.

If you have ever been in group therapy, as I have, you can relate to these benefits. But let's take a look at how they relate to photography and how they can help you as they have helped others and me on my photo workshops.

Group therapy helps you realize you're not alone. I have found that photographers, as well as most artists, are basically insecure individuals. They use their art not only for personal satisfaction, but to gain approval, a need that probably started when their parents first put one of their kindergarten finger paintings on the refrigerator and told them that they were super-talented. In a group, the photographers see and share this need, which is not necessarily a bad thing (because competition is good) within a group.

Group therapy facilitates giving and receiving support. On photo workshops, common mistakes are often made. Seeing those mistakes makes photographers realize that they are not alone, which makes the individual feel more at ease with not being perfect. What's more, seasoned photographers take the novice photographers under their wings, giving the newbie support. The experienced pro gives and the beginner receives. A winning combination that builds trust and friendship.

Group therapy helps you find your "voice." On a photo workshop, it's not unusual for participants to strive for the "iconic" shots. That's okay. But it's much more fun and rewarding to get unique photographs in iconic locations. Looking for those unique shots, or processing an image in a unique way, like making a dramatic black-and-white image from a colorful scene, helps photographers find their voice, or maybe,

put in artistic terms, their style.

Group therapy helps you relate to others (and yourself) in healthier ways. When you are in a photo workshop you are, usually, on your best behavior. However, I have seen some bad photo workshop behavior that I will share toward the end of this chapter.

When you are around other people, it's natural to try to relate to them in a positive, healthier way. You know, or should know, the effect you have on other people. This awareness can make you a better person (perhaps not being so selfish), which in turn makes us feel better about ourselves.

Group therapy provides a safety net. After leading photo workshops for more than 25 years, I can tell you that the participants often look out for each other, helping with photo gear, photo questions, and even by physically helping each other get around in difficult conditions.

The group also helps build morale when things don't go exactly as planned, such as when it rains for days in a location during the "dry season," or when a road is washed out or snow covered and the group can't get to a key photo destination.

I have also experienced situations where an individual, a novice, really needs help and guidance and support, because the photographer is depressed that he or she is "not getting the shots" that the others in the group are getting. The group comes together to provide a safety net for that person, telling the person, "Been there, felt that."

In situations like that, I add: You are not alone. All professionals were amateurs at one time, and all professionals felt at one time or another just like you.

If you have never been in a photo workshop, I encourage you to join one, which you can easily find on the web. If you go, I make this promise: the more you put in, the more you will get out. It's a good form of photo therapy.

And if it's your first photo workshop, my friend and workshop participant Alec Arons offers five keys for a successful workshop/photo walk experience:

1. Remember all of the participants are there to improve as photographers.
2. To grow, you need to experiment and try something new.
3. Share your images to get ideas and see what others are seeing.
4. Practice situational awareness and respect the environment/location and co-participants.
5. Be mindful and stay in the moment. It is not a competition. Relax, have fun, slow down, and enjoy the experience.

Good advice from Alec, for sure.

And now for the bad photo workshop behavior experience, which happened about 15 years ago in Bosque del Apache, New Mexico.

On the first day of my workshop, I stressed, among other things, the importance of being polite, kind, and courteous to the other photographers in our group—and to other photographers on other workshops who we might meet on our outings. It's just common sense.

My philosophy: We are all in this together.

Here's what happened.

We arrived on-site, in the dark, at 5:30 a.m. Several other workshop instructors and their students were already on-site. That's all well and good. First come, first served as far as getting a good position goes. That happens many times in very popular shooting locations.

Why arrive so early? The photo opportunities—countless birds in flight silhouetted by a spectacular New Mexico sunrise—are endless, as well as breathtaking.

As one of my students was setting up her tripod in an open, yet tight, spot, a photographer walked in front of her and said, rather curtly, "That's my spot."

My student responded, "It's an open spot. No one is here."

The very rude student from the other workshop said, "I was here first. I just went back to my car to get my second tripod." (It was a tripod with a second camera and a $3,000+ lens.)

We've been friends ever since, staying in touch through e-mail, sharing images and thoughts, and getting together as often as schedules allow.

"For me, that means I've pulled away from the wholly solitary pursuit of my vision to being a part of a group that keeps me on my toes creatively and challenges me to continue to improve my photography. The Posse stimulates me, challenges me to try different types of photography, and offers fair, honest assessments of my work. That drives me to be a better photographer and a better friend."

GARY SMITH: "When I attended a Rick Sammon workshop in Utah in 2013, I had a reasonable idea of what to expect. I expected to visit some iconic sites and to have some instruction on photographic techniques, if needed.

"Although our intent was to visit several of Utah's national parks, our agenda was severely disrupted because of a government shutdown. Rick and his wife Susan did a great job in finding alternative sites for us, and as a result, we visited and photographed some beautiful places and we didn't skip a beat.

"However, the best part of the workshop (though not to downplay Rick's and Susan's efforts) was to meet and make friends with others in the group. Since the workshop, Rick has dubbed us 'the Posse' and we've adopted that name. There are six of us from various parts of the United States, and we all have grown as photographers by sharing almost daily e-mails and photos, and have gone on additional trips together over the years.

"I can tell you that, without a doubt, my knowledge of, interest in, and growth as a photographer has been in large part due to my relationship with my friends, the Posse. As I stated before, that was the best part of the workshop because if I hadn't done the Rick Sammon workshop, I would never have met these true friends."

JOHN VAN'T LAND: "Like many workshop photographers, I came into

I was stunned. I said to my student, "Hang in."

I walked around for about two minutes and found a clear spot for my student. She moved into position and got wonderful images, as did all of our workshop students.

The rude student could have said, "Let's try to squeeze in here together. Let's get cozy. Let's try to make it work. We are all in this together."

Need a reminder? Listen to the Beatles' song, "All Together Now," which they play at the end of their movie, *Yellow Submarine*.

Being the positive person that I am, I'll end this chapter by sharing one of the most positive photo workshop experiences of my career. It's a compilation of comments from the workshop participants themselves. I share these with you so you know that most photo workshop participants have good behavior. They are also good examples of group photo therapy at work.

BOB WOLVERTON: "Photography, at least for me, is a solitary pursuit. I tend to go off on my own, pursing my project and trying to sharpen my vision without distraction or companions. That choice, however, can lead to creative stagnation. Without serious input, my work may not move forward. It's easy to get caught up in one project or one style when one is alone in the field. That is why I attend workshops: for a chance to expand my horizons, and encounter new ideas—and new friends.

"Sure, we all go to the same spot at the same time and trip over each other's tripod legs, but beyond that, something far more important, almost magical, happens. Attendees seem to coalesce into smaller groups that tend to stick together and seem to be more comfortable in that sub-group. We generally get along well with the rest of the workshop attendees, but that small core remains. At least during the workshop. If we're lucky, that group lasts.

"Six strangers gravitated to one another at Rick's Southern Utah Caravan in 2013. We became so close that Rick named us 'The Posse.'

Rick's Utah's workshop with many years of experience in doing things 'my way.' But the first day of the workshop, I looked around at the other members of our group and I was struck with the fact that there were many other very talented photographers among us. I felt my own doubts and limitations, and that caused me to wonder if I really could fit in with this talented group. As others introduced themselves and as I noticed the great equipment many were using, I further questioned my own ability to contribute. I later learned that others members of the group were thinking the same thing!

"But soon we all realized that we deal with the same issues—we all are uncertain of ourselves at times (or much of the time), we all struggle with basic issues—but we also found that we all have something to offer to others in the group. Although I was humbled to be a part of such a great group, yet I was thankful that I could contribute a few things and receive kind words of appreciation from the others. As we spent time together, we 'loosened up' and we formed relationships. We also learned that, although we come from many different backgrounds and have had many different life experiences, we share the common love that unites us: the desire to create or recreate beautiful images. We were able to learn together and we became friends. I realized that because of our differences, we can learn and appreciate new ways of doing things and thus we become 'richer' individuals and better photographers because of our differences. But most important, over the years we have become good friends who communicate almost on a daily basis. That's a lot more than I ever expected to get out of one workshop!"

RUSTY PARKHURST: "When I attended my first photography workshop in 2013, I had no idea what to expect. It's not something I had ever given much thought to doing, and to be honest, I was very reluctant to commit. The decision to step out of my comfort zone and venture out into the desert with my camera and a group of amazing photographers had a profound impact on me, not only as someone who

enjoys taking pictures, but also as a person.

"The primary focus for that week was photography, which in itself is a pretty cool way to spend a week. My skills certainly improved and my passion for photography grew immensely. However, there was much more at work in those few days that would extend far beyond the reach of a camera lens. There were friendships in the making. Long-lasting, meaningful relationships that would extend well beyond the confines of the workshop. That workshop was an incredible experience. Sure, I made what I thought were a few 'good' pictures. More important, I made some great friends. Connections that will last a lifetime and transcend photography. Sure, a picture may be worth a thousand words, but great friends are priceless."

Talk about the positive effects of group photo therapy! What's more, all these comments illustrate the all-important topic of the following chapter, emotional intelligence.

I'll end this chapter with an inspiring photo workshop story by my friend Marina Barayeva (marinabarayeva.com).

"On a photo workshop/photo competition in which I was participating, the organizers changed plans at the last moment and decided to move to a different site for a sunrise shoot.

"The problem was that they weren't familiar with the new site. The team woke up at about 5 a.m. and drove all the way to the new and unfamiliar location.

"When we arrived, we realized that the most beautiful view was behind the mountain that we were facing. What we saw was a gray mountain shrouded by fog, a dark river in the foreground, and some trees here and there. I almost cried. It looked ugly. However, because we were there, I decided to take some photographs with the idea of photo processing in mind.

"After the shoot, I picked one photograph and processed it. I was pleased with the results, so I submitted it for the competition. Well, it turned out that my photograph of the 'ugly' scenery received an award and was included in the exhibition."

YOUR MISSION:

Join a photo workshop, and when the light is not quite right, do as Marina did: use creative visualization to envision the end result in Photoshop or Lightroom, and follow your heart.

11.

EMOTIONAL INTELLIGENCE
FOR PHOTOGRAPHERS

*"When dealing with people, remember you are not dealing
with creatures of logic, but with creatures of emotion."*
— DALE CARNEGIE

The examples of good and bad photo workshop behavior in the previous chapter illustrate, in part, what is called emotional intelligence.

According to Wikipedia, Emotional Intelligence (EI) is the capability of individuals to recognize their own, and other people's, emotions, to discern between different feelings and label them appropriately, to use emotional information to guide thinking and behavior, and to manage and/or adjust emotions to adapt environments or achieve one's goal(s).

The concept of EI has been around for decades, and much has been written on the topic, most notably in Daniel Goleman's book, *Emotional Intelligence*.

Studies show that people with a high EI can be more successful, as well as happier, in life than people with a high IQ (the total score from several standardized intelligent tests.)

Some of the goals of psychotherapy are to be "happier," more content

and to have a better understanding of our feelings and ourselves. That can also be said, I propose, for photo therapy. What photographer wouldn't like to be more confident about their work, feel more fulfilled, and better understand what and why they photograph certain subjects?

Nota bene: I put "happier" in quotes because happiness is relative. What's more, in psychotherapy the opposite of "happiness" often happens: one experiences and learns how to bear pain.

In photography, we can feel (and can illustrate within a frame) pain, too. Just think about some of the topics, including "Saved my life," in the Introduction for this book. And think about how a still photograph can have a sad or painful effect on you and others. The 1972 Vietnam War black-and-white photograph, Napalm Girl, which shows a 9-year-old girl, crying, burning, and running naked from the fire comes to mind.

Taken by Associated Press photographer Nick Ut, it is the single photograph that helped to end the war, in which more than 58,000 American soldiers—and more than two million civilians on both sides—lost their lives.

FYI: Now a woman, the subject in the photograph, Kim Phuc, lives in Canada. Several years ago, she was awarded the Dresden Prize for her peace work.

Another equally well-known (among avid photographers) and emotionally stirring photograph is Dorothea Lange's Migrant Mother. The black-and-white photograph, taken in 1936 in Nipomo, California, during the Dust Bowl era, shows a 32-year-old destitute pea picker, Florence Owens Thompson, mother of seven children, with an aged face that is filled with despair.

Take a moment to do a Google search on these images and you will realize the power of pictures.

Of course, you can think of countless still photographs that made you smile and laugh and feel great, too, such as photographs of your loved ones, wildlife photographs that show big cats at play, and spectacular

sunrises and sunsets that are nothing less than awe inspiring and give us the "great to be alive" feeling.

One such photograph comes to mind. It's the famous photograph taken by *Life* magazine's Alfred Eisenstaedt (1898–1995) of a sailor kissing a passing woman in Times Square in New York City. It was taken on August 14, 1945. The sailor was celebrating the United States' victory over Japan.

You might want to do a Google search on the photography legacy of Alfred Eisenstaedt, whose nickname was "Eisie." I had the honor of interviewing him in 1978 when I was the editor of *Studio Photography* magazine. He, like most of the professional photographers of that time, was interested in the art and craft and power of photography, unlike today where some photographers are more interested in the number of followers they have on social media than in photography.

Okay, I know I digressed, but I wanted to reinforce the power and meaning of a still photograph, the photographs that you take. Now, let's get back specifically to the subject of emotional intelligence for photographers.

Just as we can improve our photography, we can improve our emotional intelligence, which I feel is important to being a photographer. Basically, we need to be more aware, or as my friend Hal Schmitt, a former Navy fighter pilot and Top Gun instructor puts it, we need to have "situational awareness."

When it comes to being a photographer, emotional intelligence is the key to being aware of the feelings of the people you are photographing, the people with whom you are working, and your effect on others.

Knowing one's effect on others, again as illustrated in the previous chapter, is key. The opposite of being aware is being numb, and I am sure you know or have met people who are numb.

Here are two examples of people being numb:

1. Susan and I happened upon a sacred outdoor Buddhist ceremony in Sri Lanka. A novice monk was leading dozens of

practitioners, who were sitting respectively in front of three carvings of Buddha in the side of a stone mountain, in a hypnotic chant. It was a wonderful sight and sound experience. Shortly after the ceremony started, two women with cell phones (and loud dresses) stood up and walked around taking photographs. It was disturbing to say the least. In a word: obnoxious.

2. One afternoon, Susan and I were in Zion National Park in Utah, photographing the amazing landscapes. At one location, six tourists from another country jumped a fence behind which we and several other photographers were standing— because a sign said: "Please stay behind this sign." The tourists walked into the prettiest part of the scene and proceeded to take selfies, while making silly gestures, I might add. Of course, they were wearing loud red, yellow, and green windbreakers and jumpsuits. In a word: numb.

So here is the good news about emotional intelligence: the side effect of having emotional intelligence will be that you'll be happier—or perhaps more joyful is a better term—doing what you like to do.

Here are a few examples of how emotional intelligence can work for photographers.

RESPECT THE SUBJECT: When photographing a person, every movement and gesture we make is important, so we need to be aware of our body language. Moving quickly can be interpreted as being aggressive. Move slowly and you will be less intimidating. Waving your arms around with a big gesture can also intimidate a subject, while slight,

gentle movements are more accepting.

We need to be aware of what we say, even if it is through a guide. We need to be aware of the tone of our voice. I try to speak extra gently when I am photographing a stranger in a strange land.

I also speak softly when I am photographing someone in my home studio. I am very aware of my tone, and how my subject could perceive it.

We even need to be aware that the clothes and shoes and jewelry, including a watch, we wear can have an effect on the subject. Wearing a flashy watch in a Hindu or Buddhist temple says, "this person is rich" to a subject, who may not be rich and who is not into material objects. That disconnect with values could mean a disconnection with a good photograph.

SPACE: A photographer also needs to be very aware (again, have situational awareness), emotionally aware, of space—the distance between the subject and the photographer.

It's true, the closer you are to a subject, the more intimate the picture becomes; however, if you move in too close, you can intimidate a subject. When in doubt, ask if you can get closer. Sharing your pictures on your camera's LCD monitor or smartphone gives you a good reason to get close to your subject, which might bring you "closer" to your subject.

TIME: Photographers also need to be aware of the time they spend with a subject. We need to work fast, and to be aware of not overstaying our welcome. The best way of working fast is to know your camera, so you can make fast adjustments. The best way to master your camera is by practicing, every day.

YOUR MISSION:

Do a Google search: 25 famous photographers.

12.

THE THERAPEUTIC PROCESS OF IMAGE PROCESSING

"My favorite things in life don't cost any money. It's really clear that the most precious resource we all have is time."
— STEVE JOBS

In a previous chapter, I discussed the benefits of group photo therapy. This chapter offers some ideas on the benefits of individual photo therapy, specifically about working and playing alone in the digital darkroom, and with apps on smartphones, which offer effects that equal or even surpass what one can easily do in Photoshop and Lightroom.

For many digital SLR, mirrorless, and even some smartphone photographers, image processing is an essential part of the photographic process, not only because images can be corrected (to a point), but also because this is where artistic techniques can be created and applied. My wife Susan is a good example of the latter. She has dozens of apps on her iPhone that she uses to create artistic images, images that dazzle and delight even the super-serious photographers on my workshops.

With a few clicks of a mouse or taps on the screen of a smart phone, an average photograph can be transformed into what looks like an oil

painting. Parts of an image can be blurred for shallow depth-of-field (bokeh) for a soft and dreamy effect. Flat lighting can be transformed into dramatic lighting with strong highlights and deep shadows. Cool composites can be created to look like a Salvador Dalí painting. The possibilities are endless, again, on a computer or on a smartphone.

With all these creative possibilities swirling around in our minds, and with our focus set on creating an image, we can lose track of time and focus more on our ideas—if we have the notifications on our phones switched off, our email closed, and hide the time on our computer monitor or smartphone.

Losing track of time—getting lost in our art, craft, or hobby—is a good thing, which you can read about in an article by Katherine Fusco, "If You Want to be More Productive, Lose Track of Time" You can find this article on success.com. Basically, Ms. Fusco talks about the benefits of not being distracted by technology, including getting alerts and notifications on Apple watches, which seems to be a growing (and annoying to others) trend.

In effect, all of our electronic devices and prompts can be looked at as leashes, which act like a dog strongly pulling its owner off a path during a relaxing and peaceful walk in the woods.

Getting lost in image processing, or any activity that takes concentration, can be looked at as a form of meditation, as my friend and meditation instructor Linda Marshall suggested when I told her that I don't meditate: "Rick, when you are playing your guitar, when you are in the groove, it's a form of meditation, because you are not thinking about anything else. You are focused on creating and having fun for yourself." Linda can say this with authority because she knows how hyper I am.

Following up on Linda's comment about "having fun for yourself," image processing can be a ton of fun and of course very therapeutic, not only because we enjoy the process, but because we feel a sense of adventure, discovery, and accomplishment. And that all equates to a sense of well being.

We can look at image processing as a form of self—and free—photo therapy.

I know I am not alone in thinking about the therapeutic process of image processing. So I asked some of my photographer friends to share their thoughts with me, and more importantly, with you. Read on for some image processing inspiration.

DENISE IPPOLITO (DENISEIPPOLITO.COM)

"For me, image processing is a great way to connect to my artistic side. Because I was a painter before a photographer, being able to turn my photos into works of art really appeals to me. Having the quiet time on my laptop in the late evening is a way for me to relax and really unwind. It is a form of therapy as I am totally engaged in what I am doing and all outside distraction seems to fade away. I truly look forward to my time in Photoshop especially; I feel I have complete control over my image and the only thing stopping me is my imagination.

"I don't know about you, but I find after a big shoot, I have so many images that, even with good editing and post-processing, some 'gems' are left behind. Maybe I didn't think so at the time, but years later, my attitudes and how I see the world might have shifted a bit.

"So, I go into the digital darkroom as I used to do in the days of the chemical darkroom and just get lost in looking at the others that almost got away."

GARY POTTS (IMAGESBYGARYPOTTS.COM)

"My suggestion to photographers: Go back and look at your old images. You may be surprised at what you find. I am sure your Lightroom and Photoshop skills have improved over the intervening years, giving you the chance to add value to an image you thought previously to be 'just ok'.

"For me, I look at the computer screen and see newness, spontaneity, and maybe even some renewed impact, especially when I apply new masking and selection techniques, new plug-in filters, or perhaps

convert from color to monochrome or go the other way again. Is this photo therapy as Rick suggests? You bet. Hours fly by. Time becomes meaningless and there are no texts or phone calls or distractions if you allow that to happen.

"Give it a try! Go back to your cloud files or to your external hard drives and find those gems!"

IBARIONEX PERELLO (WWW.IBARIONEX.NET)
"When I open an image in Lightroom, I see it as an opportunity to discover a moment for a second time. The making of the photograph is just the beginning, while the processing of the image provides me the means to interpret the photograph in a way that conveys the sense of both wonder and discovery that I experienced as I pressed the shutter release. It is a time that reaffirms my sense of wonder and appreciation for how I see and experience the world."

FRANK DOORHOF (WWW.FRANKDOORHOF.COM)
"For me, working in Photoshop/Lightroom can mean two things. My workflow for model photography always starts with fairly standard boring stuff like softening skin and fixing problems that couldn't be prevented on set. After that comes the creative part in the form of tinting. I'm heavily influenced by cinema, and for me the tinting process is a creative and essential part on top of the shoot itself. This is where my images come to life, so to speak. This is the process that I immensely enjoy. I get lost in the process.

"It's a different story for street and travel photography. Although I immensely love taking the shots, I usually can't wait to see those images on my computer monitor. The enhancements I do to those shots literally puts me in the driver's seat on the road to, as Rick says, creating my own 'reality.'"

ALEX MORLEY (ALEXMORLEYPHOTO.COM)
"I started my photography when I was in high school. That was way

back in the film days.

"I would shoot a roll of Kodachrome 36-exposure film, mail it in for processing, and a week or so later I would get back my slides. When that small package arrived from Kodak, I was so excited! I would get a tingling sensation up and down my spine in anticipation for placing those slides on my little light box to view them. There were times, however, that I couldn't wait to get back to the house; I would rip open the package and hold the slides up to the sky just to see if I got the shot!

"Photography was more difficult back then. There was no instant feedback on camera adjustments like we have today with our incredible digital cameras. Now, when I download my images into Lightroom, I still get that same feeling of excitement. It's like being a teenager again! I can't wait!

"Image processing makes me happy. It centers my mind. Just like the moment of taking the image in the field, processing brings me to the present. It's an awakening. At that moment, the image is the only thing that matters. And if I give that sense of awakening into an image when processing, that image—and my soul—glows."

Thank you Denise, Frank, Ibarionex, Gary, and Alex for your insights!

Your Mission:

Lose the leash of time and enjoy the moment.

13.

STEAL LIKE AN ARTIST

"Those who do not want to imitate anything, produce nothing."
— SALVADOR DALÍ

This is the shortest chapter in this book, but still an important one. One of my favorite books is *Steal Like an Artist: 10 Things Nobody Told You About Being Creative,* by Austin Kleon.

The book opens with a quote by Salvador Dalí: "Those who do not want to imitate anything, produce nothing."

Later on in the book is a quote by Pablo Picasso: "Art is theft."

You get the idea. Photographers, as well as all creatives, can learn from others by stealing (trying really hard to imitate) the work of well-known artists.

At the photography level, we can learn about how light shapes a face, how color affects the mood of a scene, how catch-lights in a subject's eyes can make the eyes sparkle, how light illuminates and shadows define, how shadows are the soul of a picture, and so on.

I have tried "stealing" many times, always giving credit to the source of my work. You can see an example of this by doing a Google search:

Rick Sammon – Girl with a Pearl Earring, a photograph that was inspired by Vermeer's painting, *Girl with a Pearl Earring*.

As strange as it sounds, "stealing" can be good photo therapy, because once again, we feel a sense of accomplishment and growth after we have learned something new.

When you steal, however, always be sure to give credit where credit is due. One photographer did not give credit and got caught. Big time. Do a Google search on The Stolen Workshop to read all about it.

Getting back to Salvador Dalí, one of his most famous paintings is his *The Persistence of Memory* (1931), commonly known as Melting Clocks. In looking at this painting, I am reminded of how time, for everyone, melts away—unlike a digital photograph that is "melt proof." That's why it's important to take photographs, especially of loved ones.

YOUR MISSION:

Steal like an artist.

14.

WRITE A CAPTION
OR EVEN A BOOK

One of the creative exercises I suggest to my photo workshop participants is to write a caption for a photograph. I say that if you can't write a caption, maybe the photograph is not "saying" anything.

It's a thought-provoking exercise that forces the photographer to really think about a photograph. It's another form of focusing, as described earlier in this book.

If you have not tried writing a caption for one of your favorite images, try it, you'll like it and you will learn from it.

Of course, not every photographer agrees with me that writing a caption is a good idea. For example, Elliott Erwitt says, "The whole point of taking pictures is so that you don't have to explain things with words." So there!

What happens if you want to write a caption and you can't, even after

trying for some time? Well, don't feel bad, because maybe the photograph, like a classical composition, says enough by itself. For example, Beethoven was able to give one of his masterpieces the title of *Moonlight Sonata*, but as good as it was, he could only name another masterpiece Opus 18.

As an aside, Beethoven wrote more than 140 opuses, according to some experts.

Writing a caption can be a form of photo therapy because it can give us a good feeling about our work. And in all forms of therapy, feeling good or better is a goal.

Writing, like taking and processing pictures, can be another form of therapy, unless you have writer's block, which can drive you crazy.

If you like writing captions, you may want to try your hand at writing a how-to book—a photography book or a book on something else you like, illustrated with your photographs, such as gardening, cooking, knitting, and so on. Talk about needing something to focus upon!

I believe that everyone has at least one book in them. If you can relate to that concept, here are 12 tips to get you started, tips that I have followed while writing my 39 books (some with my wife Susan). These tips apply to writing all types of how-to books, not only photography books.

STUDY AND KNOW YOUR SUBJECT INSIDE AND OUT

There is an old saying: If you want to become an expert on something, write a book about it.

As well as you may think you know a topic, hire (or have the publisher hire) a technical editor. He or she will probably catch stuff you miss and mistakes you make.

KNOW WHERE YOU ARE GOING

Before you start, have a detailed outline (which may change). If you don't know where you are going, how are you going to get there?

RESPECT THE READER

This might be the most important tip. When writing each sentence, respect the reader. Use appropriate language and don't talk down to the reader. Never assume anything. Remember, you are not writing the book for yourself, you are writing it for the reader. When writing your book, keep Amazon reviews in mind. You want as many 5-star ratings as possible, and you have a better chance of getting those ratings if you respect the reader and do your very, very best.

Speaking of reviews, you might want to disregard 1-star ratings. People who have a chip on their shoulders against the author, many of whom hide behind fake names, post some reviews.

LEAVE NO QUESTION UNANSWERED

Don't leave the reader asking the question: Why did the author not complete that line of thought? Go the extra mile when talking about a topic.

KNOW YOUR COMPETITION

Go online and see what other authors are doing on the same subject. Ask yourself: How can I make my book, better/different? The best?

HAVE MORE MATERIAL
THAN YOU THINK YOU NEED

You need a lot of material to write a how-to book: photos, illustrations and text.

MAKE IT EASY AND FUN FOR THE
PUBLISHER/EDITOR TO WORK WITH YOU.

Be flexible. I am not the best photographer or author on the planet, but I do pride myself on being perhaps one of the easiest when it comes to working together.

GIVE YOUR EDITOR SPECIFIC INSTRUCTIONS

For example, when I submit photographs, I tell my editor: "Crop my pictures and you're a dead man!" After which I add this symbol: :-)

PLAN AHEAD

Never miss a deadline. Give yourself plenty of time to write and edit and rewrite and rewrite and edit, etc. Remember, dates in your rear view mirror are closer than you think.

LET YOUR PERSONALITY SHOW/SHINE THOUGH

In reality, many other authors know what you know. What makes your book different? Your personality, your style. Write like you talk and don't try to write too fancy. Tell a few (just a few) jokes and personal stories. Let people get to know you.

HAVE FUN!

If you are not having fun writing your book, that will probably come through to your audience. Even if you are not having fun, write as though you are having fun. As I tell folks at book signings: "It's sometimes not fun writing a book, but it's always fun autographing one!"

PR YOUR BOOK

After your book is completed, it's really up to you to promote the book, through social media and on your website. You are the best PR agent your book can have. Get your friends to help you promote your book, too.

When I talk about writing a book to potential authors, I share these three quotes:

There is nothing to writing.
All you do is sit down at a typewriter and bleed.
— ERNEST HEMINGWAY

Writing is easy. All you have to do
is cross out the wrong words.
— MARK TWAIN

I'm writing a book. I've got the page numbers done.
— STEVEN WRIGHT

If you do a write a book and get it on Amazon, you will get all types of reviews (which impact sales) from 5-star to 1-star. This happens to all authors.

Having written 39 books before this one, I can say that some reviews offer honest comments and criticisms, while others (usually posted by people hiding behind fake names or by "Not a verified purchase") just want to blast you because they have a grudge against you or are jealous. And, of course, there are those who just don't like the book.

My favorite 1-star review: "Look what the camel dragged in." This book has a photo of a camel at sunset on the cover.

One of my favorite 5-star reviews: "Rick is a master at sharing his fine-tuned experience and knowledge with others in a way that is easy to digest."

Authors need to have a tough skin. If you write a book, be ready for those negative reviews. Keep in mind what my mother told me when I was six years old: "Not everyone is going to like you."

Also keep in mind what the Beatles' George Harrison said: "It's easier to criticize someone than to see yourself."

Here's another related quote that I found on the web by "anonymous": Successful people will always be attacked in some form or

another and usually by those that lacked the courage to reach for their dream or to make a difference in their lives or the lives of others.

YOUR MISSION:

Reach for your dreams.

15.

IT'S NEVER TOO LATE
TO BE WHAT
YOU MIGHT HAVE BEEN

"It's never too late to be what you might have been."
— GEORGE ELIOT

I truly believe, as many of my passionate photography friends believe, that the process of making pictures can transform us, even if it's only for a few minutes or hours, into a creative artist—the person we might have been. Someone who we feel is special, even if the world does not recognize our talents and creativity.

And why should we care about what the world thinks of us anyway? If all the well-known artists thought that way—Picasso with his cubist paintings, for example—we probably would never have seen them.

We need to follow our hearts, and as my mother used to say: "To thine own self be true."

If you like pictures with super-saturated colors, go for it. Don't let others say that your pictures look too grungy or too gaudy. If you like dramatic black-and-white photographs with deep, blocked up (no detail) shadows, follow your heart and don't listen to the naysayers.

Your image-making process can be very therapeutic. Enjoy it! Don't

let others with their negative or righteous comments ruin, or try to ruin, that process for you.

If you get a negative comment, keep the following words of encouragement by Marina Barayeva in mind: "When you put what people think about you or your work in first place, you let them define your life and your work; you leave your happiness in their hands. The only time when it's worth it to pay attention to feedback that doesn't align with yours is when the person is experienced enough to make suggestions as to how you might improve. The rest is just another person's opinion. Instead of searching for outside approval, become the number one fan of your work—and you!"

As the Zen saying goes: Enjoy the process and enjoy the moment. This process can often be more enjoyable than reaching the goal of photo perfection."

Japanese Zen Master Dogen explains, "If you are unable to find the truth right where you are, where else do you expect to find it?"

Here's a quote that I have shared with, and that has helped, other photographers who have felt stuck with their photography:

> *"When you are through changing, you are through."*
> — BRUCE BARTON

So the process of changing—learning a new in-camera photo technique or computer digital enhancement—can be good photo therapy, because, to use another Zen saying: Learning is health.

YOUR MISSION:

Believe in you, and become your #1 fan.

16.

THE POWER OF A PICTURE

"There is one thing the photograph must contain,
the humanity of the moment."
— ROBERT FRANK

In Chapter 11, I talked about the power of the 1972 *Napalm Girl* picture that helped to end the Vietnam War. In the same chapter, I discussed the power of Dorothea Lange's *Migrant Mother* image, which helped to bring attention to the plight of farm workers during the Great Depression. On a brighter note, I also pointed out the joy that is conveyed in Alfred Eisenstaedt's "sailor kissing a girl" photograph, taken in Times Square during the celebration of V-J day during WWII.

Since writing that chapter, a recent heart-wrenching photograph has come to light. It was taken by Associated Press photographer Julia Le Duc in June 2019. It's an overhead photograph that shows of the bodies of Salvadoran migrant Óscar Alberto Martínez Ramírez and his nearly two-year-old daughter, Valeria, floating facedown on the bank of the Rio Grande River in Matamoros, Mexico. The two had drowned while trying to cross the river to Brownsville, Texas.

The image has been shared countless times on the news and on social

media. It has become a tragic symbol of the large-scale humanitarian crisis at our southern border during that time.

I am sure you can relate to the power of the aforementioned famous photographs. But a photograph does not have to have a universal message to be powerful—for you. Let me explain.

My guess is that you have lost someone in your life who was very important to you—perhaps a mom, a dad, a grandparent, a friend, a spouse, or even a child, which is sad beyond belief.

And my guess is that you have a favorite picture of that person that brings back fond memories of your time together. A picture that makes you smile, laugh out loud, or maybe even cry.

I'll keep guessing. You look at that picture from time to time to transport you back in time to the moment when you could share your love and your life experiences with that person, who you keep alive in your heart.

Before reading on, close your eyes and think about that picture and that person for a minute or so. Then come back. Take at least a minute.

I have one such picture. I'd share it with you here on these pages but I want to keep my promise to myself that I would write a photography book without any photographs.

It's a picture of my dad. It's the last picture I took of him before he died at age 92. I think I knew it might be the last photo I took of the man who was also my good friend at the time. I think he also knew it might be the last photo.

Yes. It was difficult asking my dad if I could take the shot.

It's a natural-light portrait that I took of him seated in his study, which was my bedroom while I was growing up with my brother Bob, my editor for this book.

From a technical standpoint, the photograph shows an old man wearing a robe and a wristwatch, both of which my Mother gave him. He has a contented smile. He is leaning forward on his walker, gazing out a window.

For most people looking at the photograph, it's probably a nice por-
trait with flattering Rembrandt lighting. Rembrandt lighting, by the
way, is side lighting that shows a triangle of light on the shadow side
of the subject's face below the eye. Rembrandt lighting also illustrates a
good portrait technique: If you want an interesting portrait, don't light
the subject's entire face. Remember, shadows are your friend, and shad-
ows add a sense of depth and dimension to a photograph.

Getting back to the topic of this chapter, the photograph of my dad is
one of the most important photographs I have ever taken. I share this story
with you to illustrate the power—the personal power—of a single picture.

So the main message of this chapter is to encourage you to photo-
graph the ones you love. These photographs, even if they are just snap-
shots or selfies, will be your most important pictures—for you. Who
else really matters? Surely not all your "friends" on social media.

But there's another important message here: As photographers, we
have the wonderful gift of stopping time…forever. Looking at an image
can magically transport us to a distant moment back in time, bringing
a person, or perhaps more accurately, the memory of that person, "back
to life" as in a dream. Honestly, what could be cooler?

Combine the picture of an old man leaning on his walker with Lewis
Hine's comment: "If I could tell the story in words, I wouldn't need to
lug around a camera." The following is what one person said on my
blog about the image:

It's full of symbolic, emotional content.

Looking into the distance, contemplating the edge (the end) is near,
time (watch), space.

Life is behind him, yet he is still connected to this world (watch again).

Going through the daily cycle (circular movement in his arms, lead-
ing to his aged face).

Drawing ever nearer to the edge of darkness.

Still grounded to the earth by the cold metal of the walker.

Walker keeps him in the photo and connects him to the

photographer—his son, his future.

Carry on. Carry on my son.

In addition to all these heartfelt words, I did get one Facebook criticism. Because my dad was leaning on the walker, with his hands held together, those hands were closer to the camera than his face—making his hands appear larger in the frame than his head. "Rick," the person on Facebook said, "You are supposed to be a pro! You were too close to your dad. I can see that you used a wide-angle zoom lens that made his hands appear extra-large in the photo. My advice would have been to move back for a more proportionally-accurate photograph."

Technically, the writer of the comment was correct. But as I note on the pages of this book, it's the mood and feeling of a picture that is most important. In other words, the emotion one feels when they look at a photograph.

You see, I wanted my dad's hands to be large in the frame. Here's why: When I was growing up in that room and doing my homework, my dad would put his arms around me, and with his big hands, help me with my assignments. Back then, he was the strongest and smartest person in my life. In my photograph, I wanted to convey that strong feeling.

At the end of his life, my dad was still the smartest person I knew, but it sure was sad watching him go from the strongest person in my life to one of the physically weakest.

If you'd like to see the photograph of my dad, do a Google search: Rick Sammon We Are a Part of Everyone We Meet.

Get this: I got more comments on that photograph than on any of my exotic photographs from my worldwide travels to 100 countries. That's the power of a single photograph.

Here's a bit more about the mood, feeling and emotion of a photograph.

The Photographic Exhibitions Committee of the Professional Photographers of America (PPA) provides 12 guidelines for judging a photograph:

- Creativity
- Style
- Composition
- Print Presentation
- Center of Interest
- Lighting
- Subject Matter
- Color Balance
- Technical Excellence
- Technique
- Storytelling
- Impact

For sure, these are good guidelines. What I find interesting, however, is that the PPA leaves out the most important element in a photograph: EMOTION—the mood and feeling of a photograph. Add this element to the above guidelines and, I think, you will have a personal prize-winning photograph, and making pictures for yourself (not an organization or followers on social media) should be your #1 goal.

My friend Skip Cohn has his own "power of a personal picture" story. From Skip:

Many times over the years, I've commented that except for medicine no career field has given the world more than photography. Think about what the world would be like if the photographs we share and see were replaced by drawings!

We're all part of a creative endeavor that captures memories and gives people the ability to take intangible moments and hold onto them forever. And while that might sound incredibly sappy, I'll make my point with a short story about Molly the Wonder Dog.

Molly was a 62-pound Labradoodle. She died in February 2019 after 13 ½ years by my side every day, except when I traveled. And, if it was a road trip, she was with me even then. I never thought about losing her, and in all honesty, in my heart, she was going to be with me for my lifetime.

Liver cancer took her in February 2019, and I was crushed. Everyone who has ever lost a pet knows the feeling. The things that helped me through it all were all the photographs I have of her. Being in the photographic industry with so many friends who are artists, Molly was probably the most photographed dog in professional imaging. From still images to videos, I have an endless supply of incredible memories.

My most favorite are two black-and-white portraits captured by Robert Vanelli a few months before Molly died. I can look at them and time travel right back to the very moment I was holding her head on my lap. Sure, there are tears, but over time the tears have turned to savored smiles I cherish. Those portraits have become two of my most valuable possessions!

There's a beautiful quote by author Jodi Picoult that I've shared many times. It's so appropriate to make my point: "This is what I like about photographs. They're proof that once, even if just for a heartbeat, everything was perfect."

S. B. Cohen
SkipCohenUniversity.com

17.

THE HARDER YOU WORK,
THE LUCKIER YOU BECOME

*"Luck is not something you mention
in the presence of a self-made man."*
— E.B WHITE

When people hear that I traveled to about 100 countries—photographing and experiencing different cultures, wildlife, cities, and more—they often say, "Rick, you are so lucky!" I respond by agreeing that I am indeed lucky, but I add, "The harder I work, the luckier I become." I have worked—and still work—hard. Every day.

So the message of this chapter is that you do need to work hard to get lucky, even when you get some "lucky" breaks, as you will soon read. We also need "situational awareness (see Chapter 11) and we need to remember that we can help to create our own reality (see Chapter 5).

What's more, we need to be aware of what my Mother told me when I was about six years old: "You never know who is watching."

Here are two personal examples of my philosophies. I share them with you because I feel that if these concepts have worked—and still

work—for me, they can work for you!

THE FIRST STORY

Back in 1978, while I was the editor of *Studio Photography* magazine, I was also the editor of a magazine called *Photo Processing*. It was a technical trade magazine that went to photo labs. I loved being the editor *of Studio Photography*, but I did not enjoy editing and writing stories on photo labs.

One day, the publisher told me I had to go to Dallas, Texas, to do a story on a lab. The next week, begrudgingly, I head to Dallas. On site, I took some snapshots, interviewed the president of the lab, Bernarr Macfadden, and gathered information for an article. Boring!

Unbeknownst to me at the time, Mr. Macfadden was also the president of a non-profit international marine exploration organization called **CEDAM International**. CEDAM is an acronym for Conservation, Education, Diving, Archeology, and Museums.

When the article was published several months later, Mr. Macfadden called to say he loved it. Then he proceeded to tell me about CEDAM, and asked me if I'd like to be the editor of the group's newsletter.

Because I was fascinated with the underwater environment, having watched *Sea Hunt* and *The Undersea World of Jacques Cousteau* on television, I asked about the position. Bernarr—we were on a first-name basis by then—said that I needed to learn how to scuba dive, take underwater pictures, and travel to Belize, Central America, for my first assignment.

Speeding up this story, I did all of the above. I became the editor of the newsletter and two years later was elected the president of CEDAM International. For 20 years, mostly on vacation time, Susan Sammon and I traveled the world (including to Lake Baikal, Siberia) with CEDAM, working with some of the top marine scientists in the world on nautical archeology and marine biology projects.

Those travels and hard work resulted in one of my favorite picture books, *The Seven Underwater Wonders of the World*. Published in 1992, the book

18.

LIGHT THERAPY, COLOR THERAPY, AND COLOR BLINDNESS

"Photography in color? It is something indigestible, the negation of all photography's three-dimensional values."
— HENRI CARTIER-BRESSON

As I was thinking about and researching photo therapy for this book, I was reminded of the color therapy I was given by a chiropractor while I was being treated for my crippling back pain. The therapy involved being in a room as different colors were displayed on the walls.

I was also reminded about how much I, my wife and many of the people I know, are affected by sunny versus dark days, and how the difference in light affects our mood.

With that in mind, I thought I would add this chapter to this book, because an understanding of light and color affects our photography and plays a role in photo therapy.

Photography is about light—all about light. The word photography, in fact, steams from the Greek words that basically mean light and drawing. Combine, they mean drawing with light.

stressed the importance of protecting our fragile marine environment.

Yes, I was lucky to meet Bernarr Macfadden, but working hard on the boring article paid off.

THE SECOND STORY

Back in 2002, I had an idea for a coffee-table book on butterflies. I spent about two years almost exclusively photographing butterflies and moths. I did not have a publisher.

While speaking on stage at the Canon booth at a noisy photo show, someone in the audience (as my mother often reminded me) was watching. It was Lena Tabori, publisher of Welcome Books. Lena loved my presentation. The following week we signed a contract for my butterfly book, which is called, *Flying Flowers*.

While I was working on the book, my wife Susan asked if I'd like to have two of the butterfly images in a local photo exhibit, which was to be held in the musty basement of a local church. I said I was working on the book and did not have time for such a small project. Well, Susan used the magic word: please.

So I printed two photos for the exhibit.

Here comes another "you never know who is watching" story.

A woman came to the exhibit and then wrote about it in the local newspaper. She specifically mentioned my photographs.

Here is an excerpt from that article: "For their incisive vision, sumptuous textures and colors, and the sheer wonder these finely detailed descriptions of butterflies awaken in us, I think Rick Sammon's photographs are marvels." —Maria Morris Hambourg, *Curator, The Metropolitan Museum of Art, New York.*

With Maria's permission, I used her quote on the back cover of the book. I am sure you can imagine what that did for sales!

So yes, people are lucky, but a lucky or chance encounter can be life changing if we work hard.

Speaking of hard work, here is a story about what happened on a Friday afternoon in 1979 when I was the editor of the two aforementioned magazines.

My boss, Mr. Rudy Maschke, came into my office and told me to change the layout of two articles—immediately.

I said, "I'm sorry Mr. Maschke, I simply don't have time. Can it wait until Monday?"

He said, "Sammon, who is the most beautiful girl in the world?"

"Jaclyn Smith," who was a star of the TV show *Charlie's Angels* at the time, I replied. The actress was on my mind because as we had just featured her on the cover of *Studio Photography*.

Mr. Maschke said, "Sammon, if Jaclyn Smith called you and asked you to meet for drinks after work would you do it?"

Without really thinking, I said, "Sure!"

"Get to work, Sammon," Mr. Maschke said as he walked out my office.

The moral of this story, which I share many times in my talks, is that if you really want to do something, you will find the time.

When I talk to my students about hard work, I talk about Malcolm Gladwell's top-selling book, *Outliers: The Story of Success*. Summing up Mr. Gladwell's philosophy, which is backed up by dozens of examples (the Beatles, Bill Gates, and many more): the key to achieving world-class expertise in any skill is, to a large extent, a matter of practicing the correct way for a total of about 10,000 hours.

Hey, I know that sounds like a ton of work. But you don' do all that practicing in a year, or even in a couple of years. D or force it. Do what Anne Lamott's dad suggested to he (Chapter 8): do it "bird by bird." In other words, practice a time. Be patient.

YOUR MISSION:

Work hard and get lucky.

No light, no photograph. It's the magic of seeing and then recording light, and the different colors in the light spectrum, that enables us to relive and share a memory again and again with our neighbor or with strangers around the world.

Photo therapy, therefore, would not exist without light and color, which actually have their own forms of therapy. It's interesting and beneficial to take a look at these forms of therapy because light and color affect our mood. It's the mood and feeling of a photograph that are of the utmost importance, much more so than what f-stop or camera one uses.

Digitally processing the light and color in a photograph changes the mood of a picture. For example, creating deeper shadows in a photograph can create a "darker" mood, and "warming up" a photograph by boosting the reds and yellows can give a photograph a warmer feeling, the kind of feeling we get at sunrise and sunset.

Here is a quick look a light and color therapy.

LIGHT THERAPY: How do you feel on a dark and dreary day? How do you feel on a bright and sunny day? My guess is that the light affects—and reflects—your mood, as it does mine and that of many of my friends. That mood and feeling can be reflected in a photograph.

When the days get short in winter, as they do here in the Northeastern part of the United States, something called SAD (Seasonal Affective Disorder) occurs in some people. I feel it to some degree, as does my wife. SAD has different effects on different people, ranging from feeling a bit sad to depression.

Light therapy is exposing oneself to bright light that simulates daylight. According to the Mayo Clinic, light therapy is thought to affect brain chemicals linked to mood and sleep, easing SAD symptoms. Using a light therapy box may also help with other types of depression, sleep disorders, and other conditions. Light therapy is also known as bright light therapy or phototherapy.

Some folks in the Northeast have a time-proven remedy for SAD. These so-called "snowbirds" fly south to Florida in January and February. Not only do they find a bright, blue sky, but also days filled with sunlight are longer. FYI: At the Equator, there are about 12 hours of sunlight consistently throughout the year.

COLOR THERAPY: According to the website unsplash.com, Color therapy is an alternative therapy that uses colors and their frequencies to heal physical and emotional problems. Color therapy is also known as chromopathy, chromotherapy, or color healing.

The goal of color therapy is to correct physiological and psychological imbalances. For instance, if you're stressed, color therapy can help soothe you so that you can regain your psychological balance. If you're depressed, color therapy can be used to invigorate you and give you increased energy.

When I worked in the advertising business, one of the things that we kept in mind was the importance of color—of a product, a logo, typeface, and so on. Color represent different feelings and moods, and as photographers, we can use colors to express those moods and feelings. Let's take a look at how we in the United Sates feel about colors. I say the United States because in different parts of the world and in different cultures, colors may represent different emotions. For example, green in the United States represents a natural and good feeling, but in Latin America it can represent death and danger.

So we'll start with green. Green represents a natural feeling, but can also symbolize wealth in the United States where paper money is green.

Red can convey a feeling of excitement, passion, and danger. Why do you think fashion models wear bright red lipstick? And what about stop signs and fire trucks?

Yellow is a positive and optimistic color and can represent sunlight. Yellow can also instill a feeling of knowledge, which is why *National Geographic* magazine chose to have a yellow border on the cover.

Orange! For most people, orange is a fun, alive, exciting, and youthful color!

Here are a few examples of the impact of the color orange (the only color named after an object). When we wanted a cool car for one of our Route 66 road trips, we rented a Dodge Challenger painted "toxic orange." And when I was picking out an electric guitar, I looked for one with a bright orange sunburst finish. Also, what color do you think about when you think about vitamin C, which is good for you?

So, for many people, the color orange conveys a positive feeling. However, there are people who hate the color orange, especially when it comes to a shirt or sweater.

You could say, therefore, that orange is a polarizing color, and again has different meanings in different countries and in different religions. For example, Buddhist monks wear orange robes, and orange (saffron) is a sacred and auspicious color in Hinduism. Yet in the United States, orange is the color of some prison uniforms.

As a side note, my brother Bob, while editing this text, asked me why I spent more time on orange than on the other colors in the spectrum. The answer, I guess, is that I like the warm orange tones of sunrises and sunsets, which is why I chose an orange-tone image for the cover of this book.

Pink is probably most associated with femininity, which is why new mothers put a pink ribbon in a newborn girl's hair.

Brown is an earthy color, which is why my Earth Shoes in the 1960s were brown.

Black is about formality (a man's tux), luxury (a stretch limo), and sorrow (a widow's dress).

White is all about purity and simplicity, which is why a bride's wedding dress is white.

Blue is a calming and trustworthy color, and maybe the most popular color in the world. Who does not own a pair of blue jeans? And why do you think the Facebook banner is blue?

Purple, especially when used in clothing, can illustrate spirituality

(like the vestments worn by priests at Lent) and royalty (like the robes worn by kings).

So the next time you are composing a picture, maybe think about composing for color to express a mood or feeling. The same goes for processing an image.

Also, when you are taking and processing your pictures, think about—and truly appreciate—the wonder of seeing a full range of colors, something color-blind people can't see.

Speaking of color blind, there is a misconception about the condition. Most people assume that color-blind people only see in monochrome—in black and white. In reality, most color-blind people can see colors, but a much narrower range of colors than most of us see.

Scientists estimate that with normal vision, a person can see about 1 million different colors, but a color-blind person can only see about 10,000.

As you know by now, I like to make learning fun. Well, here is a fun, and most interesting, color-blindness exercise. Do a Google search: Coblis—Color Blindness Simulator. Once on the site, you can drag or upload a photograph into a window that simulates the different types of colorblindness.

YOUR MISSION:

Compose a picture for color.

19.

SOME THOUGHTS ON BEING A PURIST

"In America, the photographer is not simply the person who records the past, but the one who invents it."
— SUSAN SONTAG

Are you a purist photographer, one who strives only to get the best in-camera image and who is against using digital "manipulation" to enhance an image?

My guess is that some readers of this book will answer, "Yes."

For those folks, I offer the following tongue-in-cheek suggestions. As you read on, please keep in mind that this is all in good fun, but I think you will see my point.

Let's go!

A true purist would…

NEVER MAKE A BLACK-AND-WHITE IMAGE

We don't live in a black-and-white world. Remove the color from a scene and you remove some of the reality. That's surely photo trickery. What's more, a black-and-white image can be more dramatic than a straight color shot. Go for color all the time!

Never Use a Telephoto Lens

When you use a telephoto lens, it appears that you are closer to a subject than you really are. 'Fess up and always use a 43mm lens (on a full-frame image sensor camera), which is about equal to what the human eye sees.

Use a Polarizing Filter

Unlike Superman, we can't see through the reflective surface of water, which is one benefit of using a polarizing filter. Never use a polarizing filter if you are a purist.

Never Use a Neutral Density (ND) Filter

Our eyes can't slow down time, which is one benefit of using an ND filter, especially around moving water. So using an ND filter is also a no-no.

Never Use a Fast Shutter Speed

Time stands still for no man, including the purist. Using a fast shutter speed to "freeze" the action is another cheap trick to create an image with impact.

Never Use a Macro Lens

Macro lenses can produce larger-than-life-size images. I don't know about you, but I can't see, with my naked eyes, a larger-than-life-size subject.

Never Make a Photo Composite or a Montage

If you want to limit your photo fun, don't make composites using two or more images.

Never Make an HDR Image

We see in HDR (high dynamic range). HDR image processing can extend that dynamic range even beyond what we see, much like a painter takes artistic liberty to create an image with fine detail. Don't

make an HDR image if you are not interested in capturing all the detail in the shadow and highlight areas of a very high-contrast scene.

NEVER CROP A FILE
If you want to draw more attention to a subject surrounded by lots of dead/negative/boring space, don't ever crop!

NEVER USE A PLUG-IN FOR A PAINTERLY LOOK
Plug-ins can help creative photographers awaken the artist within. Keep that artist sleeping and don't use creative plug-ins.

NEVER USE PHOTOSHOP OR LIGHTROOM TO ADJUST YOUR EXPOSURE
If you can't get it 100 percent right in-camera every time, maybe take up guitar? Don't rely on Photoshop or Lightroom to tweak or enhance your photographs.

Well, I hope this chapter brought a smile to your face, and gave you some food for thought.

YOUR MISSION:

Never limit your possibilities, in your photography and in your life.

20.

MY 40 SAMMONISMS
AND ALL QUOTES

*"Sometimes I wish my first word was 'quote,' so on my death
bed I could say 'end quote.'"*
— STEVEN WRIGHT

A s you can tell from reading the opening of every chapter in this
book, I am big on quotes, because I feel a quote drives home
a concept in a few concise words.

The text of this chapter begins with what some photographers call
my "Sammonisms." These are short sayings that, like quotes, convey an
idea quickly and easily. No photos needed. Some are not my original
sayings. I've heard them in one place or another over the years, and have
adopted them to share with my students and readers, with the goal of
encouraging them to make better images.

The second part of this chapter includes the famous quotes in this book.
I've put them all together for quick and easy inspiration and motivation.

Here are those Sammonisms, 40 of them, along with brief explanations.

THE NAME OF THE GAME IS TO FILL THE FRAME

Want to make an image with impact? Fill the frame with the subject. Of course, there is something to be said about using negative space in a frame.

DEAD CENTER IS DEADLY

Don't place the subject in the dead center of the frame. Rather, place it off-center for more interesting composition. Here, too, breaking this rule can result in an image with impact if the subject is interesting.

WHEN YOU THINK YOU ARE CLOSE, GET CLOSER

The closer you are to the subject, the more detail you see and the greater the impact of your photograph. What's more, when it comes to a portrait, the closer you are to the subject, the more intimate the photograph becomes, which is one reason why I like to use semi-wide-angle lenses for environmental portraits.

THE CAMERA LOOKS BOTH WAYS

In people photography especially, the camera looks both ways: in picturing the subject, you are also picturing a part of yourself. Remember the mood, feeling, emotion and energy you project will be reflected in your subject's face and in the subject's body language. Another way to look at this: every picture you take is more or less a self-portrait.

NEVER UNDERESTIMATE THE IMPORTANCE OF A GOOD SUBJECT

Here's a question: Why do you think cosmetic companies hire beautiful, several-thousand-dollar-a-day models, and work with expert hair and make-up people? Here's another question: Would you rather have a landscape picture on your wall taken during a spectacular sunset, or a dull landscape photo taken in a thick fog? Your answers illustrate the importance of a good subject.

EXPOSE FOR THE HIGHLIGHTS

Activate your camera's highlight alert, which indicates overexposed areas in a scene. If the highlights are more than a stop overexposed, it's difficult to recover them in Photoshop or Lightroom.

USE YOUR CAMERA LIKE A SPACESHIP

Don't take all your photos at eye level. Move your camera up and down, and even tilt it to the side, for different viewpoints.

LIGHT ILLUMINATES; SHADOWS DEFINE

This one says it all when it comes to seeing and recording light. Also, remember this: shadows are your friend and shadows are the soul of the photograph.

BACKLIGHT, SHOOT TIGHT

When a subject is backlit and when you compose wide, the subject may be underexposed. Shooting tight will help your camera better determine the correct exposure.

MAKE PICTURES; DON'T JUST TAKE PICTURES

Take the time to arrange objects in a scene, use props, change positions, and direct the subject. Don't just take a picture; make a picture.

SEE EYE-TO-EYE AND SHOOT EYE-TO-EYE

When you photograph a subject at eye level, the person looking at your photograph will relate more to the subject than if you had photographed the subject above or below eye level.

TAKE THE DARN FLASH OFF THE CAMERA

Want a boring flash picture? Leave your flash in the camera's hot shoe. For more creative lighting, use a remote trigger to fire an off-camera flash.

STAY AWAY FROM OVERSATURATION

Oversaturating a photograph can result in those more colorful areas losing detail. In Photoshop and Lightroom, use the Vibrance slider rather than the Saturation slider. The Vibrance slider saturates colors that are not already saturated. The Saturation slider increases the color saturation of the entire file.

MAKE A "ONE-PICTURE PROMISE"—TO YOURSELF.

I talk about this in Chapter 7, but here again is my philosophy: When you are in a situation, imagine you only have one frame remaining on your memory card, and you can take only one picture. If you do this, and think like this, I promise you will have a more creative photograph. What's more, during a photo outing, you will have a higher percentage of creative photographs and fewer outtakes.

WE ARE A PART OF EVERYONE WE MEET

We develop our personalities, in part, by incorporating what we like about people into our lives. We become a part of those people, which I think is pretty cool. Of course, the opposite is true. What we don't like about someone, we don't incorporate into our personalities. That's a good thing.

PEOPLE WANT TO KNOW HOW MUCH YOU CARE BEFORE THEY CARE HOW MUCH YOU KNOW

This one, too, does not need any explanation.

WATCH THE WIND

Always change lenses with the wind at your back, especially when you are by the ocean. Image sensors and camera mirrors do not like salt spray.

BEWARE OF THE BACKGROUND

The background can make or break a photograph. Generally speaking,

blur the background (telephoto lens, wide aperture) for a portrait, so the subject stands out in the frame; keep the background in sharp focus (wide-angle lens, small aperture) for an environmental portrait, so the photograph looks the same way you saw the scene: everything in focus.

SHOWER WITH YOUR TRIPOD

After a day of photographing by the ocean, where sand and salt spray can get into the joints of your tripod, extend the legs of your tripod, grab it, and jump in the shower to wash away all those particles. Best to do this alone!

REMOVE REALITY

When you take the color out of a photograph, you remove some of the reality. When you remove some of the reality, a picture can, but not always, look more creative and more artistic. Just ask Ansel Adams!

SHOOT THROUGH IT

Use a foreground element—branches, a fence, the railing of a bench, and so on—to add a sense of "being there" to a photograph.

SEEK SEPARATION

We see the world in 3-D, while our cameras see the world in 2-D. When composing a photograph, move around so the elements in the scene are separated and not overlapping. This technique will add a sense of depth to an image.

EMBRACE DISTORTION

If the best professional photographer on the planet photographs a tall building or tall trees from a close-up position, the photograph would show the building or trees leaning backward and inward. That's an easy fix in Photoshop and Lightroom with Perspective Control. However, embracing the distortion can also produce a cool-looking photograph.

CALIBRATE CAREFULLY

If you are serious about your photography, you must calibrate your camera, monitor, and printer.

KEEP IT CLEAN

Always keep a lens-cleaning cloth with you. When you are using a wide-angle lens and photographing into the sun, a tiny dust spot can look like a giant blob in your photograph.

FIND YOUR FOCUS

Just because you have an autofocus camera that does not mean that your camera knows where *you* want to focus. Set your focus point or points carefully. Always.

MOOD MATTERS MOST

Tech tips are great, but the most important element in a photograph, as well as in music, is mood.

DON'T OBSESS WITH OCD

One type of OCD is Obsessive Clicking Disorder. This happens when a photographer just "sprays and prays"— taking dozens, or even hundreds, of shots, hoping to get one good shot. It's like using a shotgun. A better idea is to use the "bow and arrow" approach. Think carefully about your target photograph, and then press the shutter release button.

OBSESS WITH OCD

I have Obsessive Cropping Disorder. I always think about how a simple crop can enhance a photograph. Cropping, even if ever so slight, improves my photographs 99 percent of the time.

USE BORDER PATROL

Before taking a picture, run your eye around the image in the viewfinder

or on your camera's monitor to make sure what you want is in the frame and what you don't want is not. Do the same thing when processing your photographs.

KEEP YOUR EYES WIDE OPEN

When composing a picture, keep both eyes open, which takes some practice. With both eyes open, you have a better chance of seeing what may be coming into a scene to improve or ruin a photograph. Professional sports and wildlife photographers always shoot with both eyes open.

RIDE THE ROLLERCOASTER

Being a freelancer and working for yourself is like being on a rollercoaster: the highs are high and the lows are low. However, that "ride" is much more exciting than being on a 9-to-5 merry-go-round.

THINK LIKE A PAINTER

Painters are in control of every inch of a painting, and they lighten and darken, and sharpen, and increase/decrease contrast and saturation selectively. When working in Photoshop and Lightroom, think selectively and not globally. For example, when sharpening an image, only sharpen those areas that you want to stand out in the frame.

TAKE NOTE OF NOISE

My dad had a great expression: "If a picture is so boring that you notice the noise, it's a boring picture." Sure, always try to shoot at the lowest possible ISO to get the cleanest possible file, but keep in mind, noise can sometimes enhance a scene, removing some of the reality. Also note that some photographers, including Robert Farber and David Hamilton, built their reputations on soft and grainy photographs.

stressed the importance of protecting our fragile marine environment.

Yes, I was lucky to meet Bernarr Macfadden, but working hard on the boring article paid off.

THE SECOND STORY

Back in 2002, I had an idea for a coffee-table book on butterflies. I spent about two years almost exclusively photographing butterflies and moths. I did not have a publisher.

While speaking on stage at the Canon booth at a noisy photo show, someone in the audience (as my mother often reminded me) was watching. It was Lena Tabori, publisher of Welcome Books. Lena loved my presentation. The following week we signed a contract for my butterfly book, which is called, *Flying Flowers*.

While I was working on the book, my wife Susan asked if I'd like to have two of the butterfly images in a local photo exhibit, which was to be held in the musty basement of a local church. I said I was working on the book and did not have time for such a small project. Well, Susan used the magic word: please.

So I printed two photos for the exhibit.

Here comes another "you never know who is watching" story.

A woman came to the exhibit and then wrote about it in the local newspaper. She specifically mentioned my photographs.

Here is an excerpt from that article: "For their incisive vision, sumptuous textures and colors, and the sheer wonder these finely detailed descriptions of butterflies awaken in us, I think Rick Sammon's photographs are marvels." —Maria Morris Hambourg, *Curator, The Metropolitan Museum of Art, New York.*

With Maria's permission, I used her quote on the back cover of the book. I am sure you can imagine what that did for sales!

So yes, people are lucky, but a lucky or chance encounter can be life changing if we work hard.

Speaking of hard work, here is a story about what happened on a Friday afternoon in 1979 when I was the editor of the two aforementioned magazines.

My boss, Mr. Rudy Maschke, came into my office and told me to change the layout of two articles—immediately.

I said, "I'm sorry Mr. Maschke, I simply don't have time. Can it wait until Monday?"

He said, "Sammon, who is the most beautiful girl in the world?"

"Jaclyn Smith," who was a star of the TV show *Charlie's Angels* at the time, I replied. The actress was on my mind because as we had just featured her on the cover of *Studio Photography*.

Mr. Maschke said, "Sammon, if Jaclyn Smith called you and asked you to meet for drinks after work would you do it?"

Without really thinking, I said, "Sure!"

"Get to work, Sammon," Mr. Maschke said as he walked out my office.

The moral of this story, which I share many times in my talks, is that if you really want to do something, you will find the time.

When I talk to my students about hard work, I talk about Malcolm Gladwell's top-selling book, *Outliers: The Story of Success*. Summing up Mr. Gladwell's philosophy, which is backed up by dozens of examples (the Beatles, Bill Gates, and many more): the key to achieving world-class expertise in any skill is, to a large extent, a matter of practicing the correct way for a total of about 10,000 hours.

Some folks in the Northeast have a time-proven remedy for SAD. These so-called "snowbirds" fly south to Florida in January and February. Not only do they find a bright, blue sky, but also days filled with sunlight are longer. FYI: At the Equator, there are about 12 hours of sunlight consistently throughout the year.

COLOR THERAPY: According to the website unsplash.com, Color therapy is an alternative therapy that uses colors and their frequencies to heal physical and emotional problems. Color therapy is also known as chromopathy, chromotherapy, or color healing.

The goal of color therapy is to correct physiological and psychological imbalances. For instance, if you're stressed, color therapy can help soothe you so that you can regain your psychological balance. If you're depressed, color therapy can be used to invigorate you and give you increased energy.

When I worked in the advertising business, one of the things that we kept in mind was the importance of color—of a product, a logo, typeface, and so on. Color represent different feelings and moods, and as photographers, we can use colors to express those moods and feelings. Let's take a look at how we in the United Sates feel about colors. I say the United States because in different parts of the world and in different cultures, colors may represent different emotions. For example, green in the United States represents a natural and good feeling, but in Latin America it can represent death and danger.

So we'll start with green. Green represents a natural feeling, but can also symbolize wealth in the United States where paper money is green.

Red can convey a feeling of excitement, passion, and danger. Why do you think fashion models wear bright red lipstick? And what about stop signs and fire trucks?

Yellow is a positive and optimistic color and can represent sunlight. Yellow can also instill a feeling of knowledge, which is why *National Geographic* magazine chose to have a yellow border on the cover.

No light, no photograph. It's the magic of seeing and then recording light, and the different colors in the light spectrum, that enables us to relive and share a memory again and again with our neighbor or with strangers around the world.

Photo therapy, therefore, would not exist without light and color, which actually have their own forms of therapy. It's interesting and beneficial to take a look at these forms of therapy because light and color affect our mood. It's the mood and feeling of a photograph that are of the utmost importance, much more so than what f-stop or camera one uses.

Digitally processing the light and color in a photograph changes the mood of a picture. For example, creating deeper shadows in a photograph can create a "darker" mood, and "warming up" a photograph by boosting the reds and yellows can give a photograph a warmer feeling, the kind of feeling we get at sunrise and sunset.

Here is a quick look a light and color therapy.

LIGHT THERAPY: How do you feel on a dark and dreary day? How do you feel on a bright and sunny day? My guess is that the light affects—and reflects—your mood, as it does mine and that of many of my friends. That mood and feeling can be reflected in a photograph.

When the days get short in winter, as they do here in the Northeastern part of the United States, something called SAD (Seasonal Affective Disorder) occurs in some people. I feel it to some degree, as does my wife. SAD has different effects on different people, ranging from feeling a bit sad to depression.

Light therapy is exposing oneself to bright light that simulates daylight. According to the Mayo Clinic, light therapy is thought to affect brain chemicals linked to mood and sleep, easing SAD symptoms. Using a light therapy box may also help with other types of depression, sleep disorders, and other conditions. Light therapy is also known as bright light therapy or phototherapy.

Hey, I know that sounds like a ton of work. But you don't need to do all that practicing in a year, or even in a couple of years. Don't rush or force it. Do what Anne Lamott's dad suggested to her brother (Chapter 8): do it "bird by bird." In other words, practice a little at a time. Be patient.

YOUR MISSION:

Work hard and get lucky.

18.

LIGHT THERAPY, COLOR THERAPY, AND COLOR BLINDNESS

As I was thinking about and researching photo therapy for this book, I was reminded of the color therapy I was given by a chiropractor while I was being treated for my crippling back pain. The therapy involved being in a room as different colors were displayed on the walls.

I was also reminded about how much I, my wife and many of the people I know, are affected by sunny versus dark days, and how the difference in light affects our mood.

With that in mind, I thought I would add this chapter to this book, because an understanding of light and color affects our photography and plays a role in photo therapy.

Photography is about light—all about light. The word photography, in fact, steams from the Greek words that basically mean light and drawing. Combine, they mean drawing with light.

PLAY HIDE AND SEEK

It's true: A photograph hides more than it reveals. By taking a photograph, you are revealing what you want to reveal in a scene, and hiding everything else.

GO FOR GESTURE

In portraiture, gesture can be a facial expression, hand movement, body language, and so on. In seascape photography, gesture can be the movement of crashing or smooth waves. In wildlife photography, gesture can be the position of a bird's wings or the wide-open mouth of a roaring lion. When I am looking to choose the best shot from a series of photographs, gesture is a major consideration.

COMPOSE FOR COLOR

Need a composition idea? Take a walk in a city, look for color, and compose for color. Look to see how strong or subtle colors work together to form an image with impact.

YOUR MONEY CAN
WORK HARDER FOR YOU THAN YOU CAN

Invest and save as much money as you can. While you are sleeping, napping, fishing, taking pictures, or taking a walk, your investments will be working for you, generating more money (as long as you invest wisely and the stock market goes up).

IT TAKES A
LOT OF PEANUTS TO FEED AN ELEPHANT

This is a follow up to the previous Sammonism. Save as much money as you can, even if it's only "peanuts." Over the years, all those peanuts will add up and can help "feed" your retirement, during which you can travel and take more pictures, maybe even pictures of elephants on an African safari.

Don't Delete

If you get an out-of-focus picture, don't delete it! One out-of-focus picture is a mistake; 20 out-of-focus pictures is a style.

Okay, it's time for the quotes in this book.

"If I could tell the story in words, I wouldn't need to lug around a camera."
— Lewis Hine

"You don't drown by falling in water. You only drown if you stay there."
— Zig Zigler

"Learn from yesterday, live for today, and hope for tomorrow. The important thing is not to stop questioning."
— Albert Einstein

"I think everything in life is art. What you do. How you dress. The way you love someone and how you talk. Your smile and your personality. What you believe in, and all your dreams. Life is art."
— Helena Bonham Carter

"If you are seeking creative ideas, go out walking. Angels

whisper to a man who goes for a walk."
— RAYMOND INMON

*"Everything you see exists together in a delicate balance. As
king, you need to understand that balance and respect all the
creatures, from the crawling ant to the leaping antelope."*
— MUFASA, DISNEY'S *LION KING*

"Reality leaves a lot to the imagination."
— JOHN LENNON

"You've come to the right place."
— DR. JOHN E. SARNO

Photography is a kind of virtual reality."
— STEVEN PINKER

"Few people have the imagination for reality."
— JOHANN WOLFGANG VON GOETHE

*"In my opinion, there is no aspect of reality beyond the reach
of the human mind."*
— STEPHEN HAWKING

"We don't create a fantasy world to escape reality. We create it to be able to stay."
— LYNDA BARR

"What you dwell upon, you become."
— BUDDHA

"It is done unto you as you believe."
— JESUS

"Whatever a person's mind dwells on intensely and with firm resolve, that is exactly what he becomes."
— HINDU EXPRESSION

"We do not see things as they are, we see them as we are."
— AS WRITTEN IN *THE TALMUD*

"We become what we think about all day long."
— RALPH WALDO EMERSON

"If you can dream it, you can do it."
— WALT DISNEY

"Change your thoughts and you change your world."
— NORMAN VINCENT PEALE

"You see it when you believe it."
— DR. WAYNE DYER

"A photograph is usually looked at—and seldom looked into."
— ANSEL ADAMS

"Learning is health."
— BUDDHIST PROVERB

"Stay away from negative people.
They have a problem for every solution."
— ALBERT EINSTEIN

"The path to greatness is along with others."
— BALTASAR GRACIAN

"When dealing with people, remember you are not dealing
with creatures of logic, but with creatures of emotion."
— DALE CARNEGIE

"My favorite things in life don't cost any money. It's really
clear that the most precious resource we all have is time."
— STEVE JOBS

"Those who do not want to imitate anything,
produce nothing."
— SALVADOR DALÍ

"In America, the photographer is not simply the person who
records the past, but the one who invents it."
— SUSAN SONTAG

"Writing is easy. All you do is stare at a blank sheet of paper
until drops of blood form on your forehead."
— GENE FOWLER

"It's never too late to be what you might have been."
— GEORGE ELIOT

"Photography in color? It is something indigestible, the nega-
tion of all photography's three-dimensional values."
— HENRI CARTIER-BRESSON

"When you are entrusted with an assignment,
you do your best."
— TU YOUYOU

YOUR MISSION:

Come back to this chapter and read a quote or two if you need some inspiration, motivation, or some quick photo advice. Keep a Sammonism in mind if you need some quick photo advice.

21.

WITH A LITTLE HELP
FROM MY FRIENDS

"I get by with a little help from my friends."
— The Beatles

In the photo industry, as well as in any industry (and in life), the key to success is realizing that "we are all in this together." Or as Baltasar Gracian says, "The path to greatness is along with others."

For sure, I would not be doing what I am doing today if it were not for a little, and in some cases a lot, help from my friends (and that includes my parents).

In this chapter, three of my good friends—Steve Brazill, Ron Clifford, Derrick Story and Randy Hanna—share their thoughts on *Photo Therapy Motivation and Wisdom: Discovering the Power of Pictures* with us. How lucky are we?

Let's go.

Steve Brazill: *It's the Art That Defines Us*
stevebrazill.com
To begin, I found it interesting and surprising that organizing my

thoughts for this chapter was very therapeutic. So as Rick suggests on the preceding pages, give writing a try.

I know this book is about photography, but in the interest of "motivation and wisdom," which after all is in the title, I would like to start with a chat about music.

Rick mentions in the Spoiler Alert section that Ansel Adams was a musician, and that many of his photography friends are also musicians. I loosely fit into that group. I grew up playing guitar, and although I don't really play anymore, I am surrounded by music. I have been on the radio for almost 40 years, and as a photographer, I photograph live music. For me, music and photography are forever joined together.

The best way I can explain how I see the power of a photograph is to start with music. A number of years ago, I was trying to develop an introduction for a TV project I was going to do for the city TV station where I live. The premise of the show, which was originally called *On Stage,* and later, *In Studio,* was to look at the local music scene by interviewing musicians and bands that in some way had a connection to the city. As I sat down to write the intro, something instantly popped into my head, and no matter how hard I tried to come up with something else, I just kept coming back to that original thought.

"We define the most important moments of our lives by the songs that were playing at the time."

Think about that for a second, I'll wait....

Hi again, and thanks for coming back.

Let's take a look at this idea of songs being a defining data point in our lives.

I twice wore out 8-tracks with Aerosmith's "Toys in the Attic." That was my high school years. AC/DC's "Back in Black" was when I worked in the liquor store. And then there is Van Morrison's "Have I Told You Lately?" Yeah, that one is special. It was my first dance song.

I could go on, but I think you get the idea. Those songs are as important to me as the moments they defined, and that's because they

trigger those usually, but not always, wonderful memories. They cause my mind to actually picture the moments, and re-live them in my mind. And let's be honest here, there-living is often better than it was being there.

Music is a powerful thing, but now let's add a visual to this concept. Photos don't just define these important moments in our lives, they are the moments Think about that for a moment.

My wife texted me a photo the other day of her with our son when he was maybe two or three years old. My son is now 26, but instantly I was right there, back in that moment, looking at the two most important people in my life. Wow. That photo made me feel so many emotions. It made me smile, it made me happy, I got a little quieter, and I got a bit teary-eyed.

That's what pictures do. I'm actually glad there are no images in this book. I don't want you to just see my memory, I want you to see yours. Picture it in your head, or better yet, go look at some of your photos.

Now, let's mix the music side of things together with the photography side. I've been into music my entire life. I remember walking down the street with friends singing Led Zeppelin's "Black Dog" out loud at 10 p.m. at night, until someone yelled for us to stop (we weren't very good). I remember riding a ski resort chairlift, singing David Allan Coe's "You Never Call Me by My Name" at the top of our lungs—yeah, I was that guy. And I remember identifying with these artists, these bands that meant so much to me, by the photos of them in magazines, on albums, and on the posters on my bedroom wall. In many ways, the images created by the likes of Jim Marshall, Baron Wolman, and Neal Preston defined my youth.

Think about the following moments and I bet you can probably remember many of the photographs: Robert Plant at the Forum, Hendrix lighting his guitar on fire at the Monterey Pop Festival, Queen at Live Aid, John and Yoko in their "Give Peace a Chance" bed, and Johnny Cash at San Quentin.

Now let's take a look at some perhaps more well known photographs.

See if you can see them in your mind's eye: Muhammad Ali standing over Sonny Liston, V-J Day in Times Square with the sailor kissing his girl, Salvador Dalí with the flying cats, and the Hindenburg disaster.

My point is that, while music is an integral part of the defining moments in our lives, photography triggers our visual and emotional memories.

The next time you take a photograph, stop and think about that concept. What is the story your photo will tell? That story is the "Power of Pictures," which is in the subtitle of Rick's book.

In closing, ask yourself: How will your art define you, and how does photography define us?

Ron Clifford: *It's Not About the Camera*
ronclifford.com

There, I said it. I know that sounds odd coming from a photographer, but when I write my first book, it's going to be called, *It's Not About the Camera; It's About Connection.*

When Rick asked me to make a contribution to his book about the journey of photography, which for me has had a few big wins and more than a few crushing defeats, I knew right away what I wanted to share.

You see, after many years of chasing a dream, and chasing the money, and chasing what I thought I "ought" to do, I have come to realize something very important: What really matters in life is being able to use your unique gifts and character in service to others and to the world, even if that contribution isn't "monumental." Reaching just a single person can be very satisfying, too!

The bigger realization is that my camera connects me to others, it connects me to the world around me in a meaningful way, and it connects me to my own humanity. What a gift for me, and what a gift you have...even if you have not realized it yet.

So here's the deal: I'm a bipolar photographer, and I mean that in every sense of the word. Not only have I been able to travel to the ends of the earth—the Arctic and Antarctica—as a photographer and guide, but I have also overcome the debilitating effects of bipolar disorder, leading a life less ordinary.

In 2007, after years of misdiagnosed mental illness, I finally received an accurate diagnosis. This was one of those times where everything that happened before that moment was separated from everything that happened after it. This was my tipping point. With proper treatment, and with the loving and generous support of those around me, I began to heal, I began to recover, and I began to lean into my own unique rhythms.

I always say, "Do what you can't help but do," and for me that is to use my camera to capture the beauty and character in the people I meet and the places I travel to, and to help others do the same. I now have the best job in the world!

A LESSON FROM THE STORMS

Sometimes, the only way to the other side of a situation is going through it, as was the situation on my first trip to Antarctica during two rough storms as we were crossing the Drake Passage.

The Drake Passage, which you need to cross by ship from Ushuaia, Argentina, to Antarctica, is considered to have the roughest seas on earth, and on this trip, she wasn't going to disappoint.

I had never been seasick before. I'm going to get a tee shirt that says, "I never get sea sick, but when I do, it's on the Drake Passage."

Toward sunset one evening, we were hitting some pretty big waves. There were some real bow crashers, and one wave in particular left me with one of life's most valuable lessons: sometimes the only way through the storm is through it. It was true about that first journey and it's true about life. Going through life's storms can give us unique experiences and understanding we can gain no other way. Going through the tough stuff can give us unique perspectives that we can use to help

others get through their own storms. I've become grateful for the "hard times" and it has led to deeper peace and greater joy.

A Lesson From the Penguins

Recently, I had a revelation, or perhaps it was a realization. Okay, let's call it a "revilization." Yeah, I made up that word.

I realized why it was that I felt so connected to the polar regions, especially Antarctica. It had gripped me from the first time I visited. One thing I realized was that seeing the world through my camera and travelling to these remote and beautiful places takes me out of my comfort zone and helps me live in the moment. It creates a sense of being present I had never felt before.

I also realized that life thrives there in spite of the harsh and relentless forces against it. Life found a way to thrive in some of the harshest environments on earth. Let's consider the penguins, and who doesn't love penguins? If there is something we can learn from penguins, it's that they thrive together. They are in it together as couples, they are in it together as families, and they are in it together as a community. They not only survive in remarkably harsh environments, they thrive!

A Lesson From the Icebergs

I'd like to leave you with a profound lesson I learned observing and photographing icebergs.

There is just something about icebergs and polar ice that resonates deep within my soul. I know I'm not alone, and I know Rick feels the same way.

Icebergs are fantastic floating works of art that are created when large sections of an ice shelf break off and are released to the ocean, or when huge walls of ice calve off a glacier and crash into the sea. It's a powerful dramatic scene to witness. This is the birth of an iceberg as it begins its life in the ocean.

Most of us know that about 90% of an iceberg is underwater and we

only see the top 10% or so. What's happening to the iceberg below the surface is fascinating. The underwater ice is being carved and shaped by the relentless forces of the ocean around it. This continual eroding and shaping of the ice causes the bottom to melt and erode and break away, until eventually the ice below the surface becomes lighter and lighter.

At a point, the ice below the waterline becomes lighter than the ice on top. It becomes unstable and the iceberg flips. It reaches its tipping point. It flips to reveal some of the most unique and beautiful sculptures I've ever seen. If you have ever seen icebergs on a cloudy day, they seem to glow from within with the most beautiful radiant blue. It's as though they have their own light source!

I believe what is true about the iceberg is true about you, and it's true about me. We are made unique and beautiful, not in spite of life's forces against us. We are made unique and beautiful because of them.

So you see, it's really not about the camera at all. It's not about the gear, or the technology, or the tools that I use to create images. It's about the experiences, communities, and connections my camera helps me create.

Rick here: Ron's story reminds me of a joke about being seasick: "There are two stages of being seasick. Stage 1: You feel as though you are going to die. Stage 2: You wish you were dead." Personally, I have experienced both stages.

DERRICK STORY: *JUST OUTSIDE OUR DOOR*
thenimblephotographer.com

For some time now, I've understood that writers need to read quality works and photographers should study great images in order to improve their craft.

The impact of this activity might not be obvious at first. But over

time, these positive influences will seep into the deeper recesses of creative consciousness.

Writers, for example, will hear the meter of the language they read. They might not realize it, but their brain will remember the patterns that make one sentence effortlessly flow into another. And at some point, these melodies will mingle with their own written expression.

This works for photographers, as well. They can examine a print and dissect how the composition is constructed, then emulate it in their own creations. And beyond that, they may also feel how the image touches their emotions. Realizing that a picture can have this power is an important moment for a photographer. I've experienced this myself.

But what I didn't realize was that these encounters don't need to be limited to the confines of our own craft. Photographers can step out of the frame into other forms of expression. That's because an artist is an artist, regardless of the particular medium that he or she chooses. Photographers who explore creativity outside of their specialty will see the world from different angles. And I believe that this will help them make better images.

I decided to test this theory with a series of interviews that I'm sharing on a podcast called *The Nimble Photographer*. I wanted to find out if I could improve my pictures by learning from musicians, illustrators, filmmakers, street artists, and yes, other photographers.

After just a few months, I can say that I'm blown away by what I've heard. Here are just two of the lessons that have emerged from these conversations.

LESSON #1

George Shaw, Musician—"Say Yes.": At a young age, George learned that his ticket out of the rural South was through education. He was both studying and playing music along the way. What he didn't realize at first was that his formal education would intersect with his creative expression. And that's what propelled his success.

I learned a couple of things from George. First, the importance of

developing your awareness to recognize opportunity, then knowing when to seize it.

He doubled-down on this skill by leaning toward saying "yes" when presented with something new, even if he wasn't totally comfortable with the challenge. This approach led him from one adventure to another, helping him develop as an artist along the way.

When I asked him for advice for upcoming musicians, he responded with, "Know your craft." It's one thing to be in the right place at the right time, but it's another to take full advantage of that situation. You have to be excellent at what you do, or opportunity will be wasted.

In his case, musical skills were vital. But his advice also applies to my work as a writer and photographer. Job one for me is to know my craft. George reminded me of that important lesson.

LESSON #2

Tom Rodrigues, Illustrator—"Nobody Bats a Thousand": One of the questions that I ask every artist is how they define success. You would think that recognition and financial reward would be at the top of every list.

The reality is that it's more complicated than becoming rich and famous. Every artist that I've talked to acknowledges that business has to be part of the equation if they are going to continue their creative pursuits.

But what I learned from Tom Rodrigues, an illustrator, is that financial reward is bigger than any single project. Creative people fail all of the time. If something doesn't work, learn from it and move forward. The value of our efforts is more than revenue and praise. Projects that don't succeed financially are just as important as those that do because of the lessons gained from the experience.

Tom achieved financial success through his innovative designs of wine labels. But he also lost money endeavoring big projects that he loved. They just didn't work out. His definition of success is becoming a better artist. Creatively figuring out how to pay the bills along the way is part of the art.

FACETS OF THE SAME DIAMOND

Bringing all of this back to the world of photography, I realize that if I open myself up to other artists, I can learn from them and energize my own craft.

This is advice that I'm also sharing with photographers who complain about falling into a non-creative rut. Instead of trying to solve the problem by grasping at new cameras or running off to exotic destinations, why not investigate the world of music, painting, theater, and other art forms, as well?

A simple start is to visit a museum and study the paintings housed inside, really looking at the use of color, line, and composition.

Then go beyond that. Listen to how Mozart constructed a symphony, or see how the lighting helped create the mood for a theatrical performance. And what about the challenges those artists overcame to achieve their success? I bet that's interesting.

Maybe go so far as, when presented with a creative roadblock, ask, "What would Meryl Streep or Andy Warhol do?"

I find it comforting to realize that I am part of a larger creative community that spans well beyond photographers. Many of the things that energize me also fuel musicians and actors.

My quest is to learn as much from them as possible, and bring that knowledge and inspiration to my own craft—and hopefully to yours, as well. I realize that every lesson might not be a perfect fit. I will pick and choose accordingly.

The important thing is to realize that there's an endless supply of inspiration in the world. We just have to look for it. Why settle for a microwave dinner when there's an entire feast just outside our door?

RANDY HANNA:
PHOTOGRAPHY IN THE "FLOW STATE"

randyhannaphotography.com

Did you ever have the following experience?

After completing a challenge or task, did you feel as though time stood still? Was your mind quiet? Were you completely immersed in your task? Did you think, "I was on a roll or perhaps on a super roll?"

If so, you are not alone. Some people call this experience being in a "flow state" or "in the zone." It's a state in which researchers report an improvement of 300 percent to 500 percent in any given skill set.

For the professional athlete, muscle reaction time automatically speeds up. You may have heard a professional athlete talking about the game "slowing down." In fact, they are talking about a state of increased awareness and heightened performance, where time appears to stand still to some extent. Suddenly, the athlete can anticipate the next move of their opponent and respond appropriately and quickly because their muscle memory is automatic, thanks to years of training and conditioning.

When one is in "flow state," thinking and problem-solving skills accelerate, possibly allowing the individual to visualize and act on things or techniques that were previously unknown to them or buried somewhere deep in their memory. Logical "Ah-ha!" moments come to mind, but at an increased speed and with potentially more impact.

Simply put, being in a "flow state" or "in the zone" is being in a state of peak performance. Athletes are always trying to enter this state in their quest for a winning performance. As one photographer to another, I submit to you that you might enter this zone without knowing it, yet you know something is different when you look at your results. Maybe you ask yourself, "How did I do that?"

Two leaders in state of performance research, Jeanne Nakamura and Mihaly Csíkszentmihályi, tell us that several things happen when in a state of flow:

- Concentration becomes pinpoint with laser-like focus;
- Actions and awareness merge;
- There is a sense of personal control over the situation or activity;
- The sense of time is distorted;
- The experience of the activity is rewarding.

As for me, I know I often enter the "flow state" when I am photographing (usually by myself) or editing. While this does not occur all the time, when I enter this state, I know something magical is happening, which can be seen in the end result.

As I pick up my camera in the flow state, years of experience and training kick in. I read the light correctly, and then using my muscle memory to control the camera, I effortlessly—without thought or mental gymnastics—make instant changes to capture rapid or subtle changes in light. On safari, I will add my knowledge of animal behavior to anticipate movement, again making split second decisions to capture the moment. Those who have observed me during these times remark that I become very quiet, my breathing slows, and my body language noticeably changes. This results in minimal movement and intense concentration.

Photo editing is another activity in which I enter the flow state. Having previously selected multiple images to edit, I approach the processing session excited and ready to create something special. My mind is on point, on task, and ready to go. Before I know it, time seems to have frozen and hours have passed—I have forgotten to remind myself to stand up, drink water, or take a break for food. However, with my images now looking as I envisioned them, the sense of completion and fulfillment is nearly overwhelming.

Frequently, the images that I capture and process during this heightened state of performance are far superior to those otherwise captured or processed.

While there are a great many articles published on how to enter this

flow state, it just seems to effortlessly happen for me—not all the time, but frequently enough that I can recognize when I have been there. I believe this occurs, in part, because I so thoroughly enjoy the creative process and am passionate about generating something intriguing, eye-catching, or thought provoking.

So, my friends, think about how you engage in the creative process of photography. Does it excite you? Do you enjoy the challenges of seeing and creating? Of concentration and control? Perhaps you can now recognize when you've previously entered the flow state—and what it felt like and how you can look for opportunities to experience it more often in the future.

YOUR MISSION:

Visit with these awesome photographers/educators on their websites.

22.

YOUR MISSION, SHOULD YOU CHOOSE TO ACCEPT IT

"When you are entrusted with an assignment, you do your best."
— TU YOUYOU

W hen I was growing up, my brother Bob and I, along with our dad, loved to watch the television show, *Mission Impossible*. It's where Tom Cruise got the idea for the *Mission Impossible* movie series.

At the start of each show, the main character, Mr. Jim Phelps, and his team were given a seemingly impossible mission via audio recording that self-destructed after being played. In the recording, Mr. Phelps was told by his superior, "Your mission, Jim, should you decide to accept it…."

Well, my friend, I have a mission for you, one that I hope you accept. That mission is to give yourself a daily (or weekly) assignment, an assignment that you can accept from the list below. Like the missions in the television show, they are not impossible to achieve, you just need to make a concentrated effort.

Basically, this "Mission List" is a compilation of some key ideas that I covered on the preceding pages. It can serve as a quick reminder of some of the benefits of photo therapy.

But first, here is a mission I have for you that has not been previously mentioned: photograph your toilet. I know that may sound strange, but hey, if it worked for Edward Weston—considered to be the most influential American photographer of the 20th century—it can work for you.

Before reading on, you may want to do a Google search: Edward Weston Pepper #30. It's a black-and-white photograph with very soft lighting of a green pepper. Most people describe the photograph in one word: sensuous.

Gearheads marvel at the exposure: 4+ hours at f/240. That f/240 aperture is not a typo. Because Mr. Weston was photographing with his view camera very close to the small pepper, he needed to make his own small aperture for good depth-of-field, basically turning his view camera into a pinhole camera.

Returning to the toilet, so to speak, here is how Mr. Weston explained the process and concept: "I have been photographing our toilet, the glossy, enameled receptacle of extraordinary beauty. Here was every sensuous curve of the 'human figure divine,' but minus the imperfections. Never did the Greeks reach a more significant consummation to their culture, and it somehow reminded me, forward movement of finely progressing contours, of the Victory of Samothrace."

For those of you who do not know about the Greek sculpture to which Mr. Weston is referring, the Winged Victory of Samothrace, also called the Nike of Samothrace, is a marble Hellenistic sculpture of Nike (the Greek Goddess of victory), that was created in about the 2nd century B.C. Since 1884, it has been prominently displayed at the Louvre museum and is one of the most celebrated sculptures in the world (according to Wikipedia).

So, my friends, have fun and be creative photographing in your bathroom! Or, run down to the supermarket and pick up a green pepper.

Okay, let's got to those other, perhaps easier, missions!

ASK YOURSELF, "WHAT DOES YOUR PHOTOGRAPHY MEAN TO YOU?"

Ask yourself that question from time to time. Your answer may change. That's part of the growing and learning process. Keep a journal to track your evolution as a photographer.

NEVER GIVE UP

Remember that photography, like all creative endeavors, is like a roller-coaster ride—the highs are high and the lows are low. But keep this philosophy in mind: being on a rollercoaster is much more exciting than being on a merry-go-round. When you are feeling low, think about the highs that you have had, and think about how you can get back up there.

STAY HEALTHY AND KEEP FIT

Exercise as much as you can and try to eat smart. The healthier you are, the better you feel and the more energy you will have when you are out photographing. Download a fitness tracker or utilize the step counter on your smartphone. Also, cut back on the carbs.

CONSIDER THE SPACE-TIME CONTINUUM

Remember that you convey a feeling with time (the exact moment you take a picture) and space (your unique and special composition). Remember that you and your photographs are special. When composing a photograph, keep that specialness in mind.

PHOTOGRAPH ANIMALS

If you can't go on an African photo safari, visit a zoo or wildlife park and enjoy making pictures. Enjoy the process as much as the end result.

CREATE YOUR OWN REALITY

Always keep in mind that you are constantly creating your own reality, with your thoughts and with your actions. Read and re-read chapters of Dr. Wayne Dyer's book, *Real Magic,* and Pam Grout's book, *E2.*

THINK ABOUT MY ONE-PICTURE PROMISE

When you are in a situation, think about the one picture you would take if you could only take one picture. Consider composition, camera settings, exposure, lens selection, background, and focus before you take that one shot.

FOLLOW YOUR HEART AND ENJOY THE PROCESS

Don't let the naysayers get you down. Believe in yourself. Always.
Join a Photo Workshop. Make new pictures and make new friends. Both will last a lifetime.

STEAL LIKE AN ARTIST

Try to copy the work of famous photographers and painters to learn about light and composition and, when it comes to people, posing. Remember, always give credit where credit is due.

BELIEVE IN YOU

There is a big difference between having a big ego and a strong ego. Believing in you is having a strong ego. Believing your own BS is having a big ego. Make a sign and put it over your desk: Don't Believe Your Own BS.

LOSE THE LEASH

When taking or processing your pictures, turn off (lose the leash) your smartphone's alerts, email, instant messaging, WhatsApp, and even the date/time indicator on your computer. Get lost in your work and you will have more fun.

TAKE A PICTURE EVERY DAY

Take a picture every day and learn something new, even if that picture is a self-portrait.

WRITE

Write a caption for a favorite photograph. Think about what that photograph says. Need some inspiration for captions? Pick up (or read online) a copy of *National Geographic* magazine. The captions are the first thing, and sometimes the only thing, most people read in the magazine.

GO BACK

Go back to the same nearby location over and over again and promise yourself that you will come home with a different kind of picture, or that you will process the picture in a new way. Try using a different lens or aperture/shutter speed combination.

JOIN FOR THE JOY

Join a meet-up group or a camera club. Share what you know and learn from others. Make new and like-minded friends who can help you on your path to becoming a better photographer. And speaking of friends, as Susan Sammon says, "You need to be a good friend to make a good friend." Or as Ralph Waldo Emerson said, "The only way to have a friend is to be one."

CHANGE IT UP

As the saying goes, "When you are though changing, you are through."

Learn a new camera or digital darkroom technique every week. In one year you will learn/know 52 more things that you did not know the year before. Make a list, starting with #1, of what you recently learned.

HAVE FUN

As always, remember this: If you are not having fun, you are doing something wrong. Surrounding yourself with positive/fun people can help you achieve this goal. Keep this adage in mind: Stay away from negative people. They have a problem for every solution.

Okay, I have one more mission for you: Photograph the steam rising from your coffee or teacup when you get up in the morning. Place the cup by a window. Photograph toward the window (the cup is backlit) and then away from the window (the cup is front-lit). Notice how the steam looks very different in each photograph. My guess is that you will prefer the photograph with backlighting, as the steam is more pronounced in the frame.

This simple mission illustrates the importance of seeing the light. What's more, you can use this technique if you go to Yellowstone National Park and photograph Old Faithful during an eruption. As I say on the previous pages, what you learn in one area of photography you can apply to another.

Good luck, have fun, and never give up on your missions!

APPENDIX:
ONLINE CLASSES
WITH PICTURES!

I also have several classes on KelbyOne.com:
Uncovering the Magic of the Rainforest
Uncovering the Magic of Utah's National and State Parks
Uncovering the Magic of Yellowstone and the Grand Tetons
Improving Your Creative Vision by Getting It Right in Camera
The 20 Time-Proven Rules of Composition
Rick's Top Tips for Taking Incredible Travel Photos
Breathtaking Bird Photography
Composition: The Strongest Way of Seeing
How to Stay Motivated in Photography
Transform Your Home in to a Professional Photo Studio – Part I
Transform Your Home in to a Professional Photo Studio – Part II
Capturing the Wild: Safari Photography

DAYS IN MY LIFE

I am often asked, "Rick, what's your specialty?" I reply, "My specialty is not specializing, because I like all types of photography: people, landscape, seascape, close-up, studio portraiture, nighttime, and more."

That being said, when it comes down to it, I enjoying photographing people most of all, especially when it comes to photographing strangers in strange lands.

Yes, being a photographer and photo educator is a big part of my life, but it's not my only life. Here's my son Marco's take on what I do. When we were together at a neighborhood party, someone asked me what I do for a living. I said, "I am a photographer." After my reply, Marco said, "Dad, you're not a photographer, you're an entrepreneur who happens to be a photographer."

In a way, he's right. All successful photographers know that the business side of photography is the key to success. We spend more time on the business side of photography than we do on making pictures. We have several different sources of income: workshops, seminars, apps, online classes, books, magazine articles, print sales, podcasts, and sponsors.

One of main reasons for me being able to do what I do is Susan Sammon. Susan runs the business side of Sammon & Sammon, helps me on-location with my photography, plans our trips, and organizes our healthy meals. What's more, because time moves at a different speed

for me (much faster than it does for most people), Susan is the only person on the planet who can work with me.

On the preceding pages, you read about my 39 books, more than a dozen online classes, international workshops, and seminars. That's the photo side of my life. Here is some stuff about the other side of my life.

I play guitar more than I take pictures, and I have more guitars than I have lenses.

When I come home from a trip, the first thing I do is mow the lawn. I love mowing the lawn. I also enjoy shoveling snow.

Being heathy is my #1 priority. I do two 45-minute walks a day, one in the morning and one in the afternoon, without a camera. The ideas for my books and online classes often come to me when I am walking.

I try to eat healthy.

I take a nap ever day after lunch. My nap is very important to me. Here's why: sleep experts have found that daytime naps can improve many things—increase alertness; boost creativity; reduce stress; improve perception, stamina, motor skills, and accuracy; enhance your sex life; aid in weight loss; reduce the risk of heart attack; brighten your mood; and boost memory (from yurielkaim.com).

If you'd like to visit more with me, swing by ricksammon.com. There, you will find my email address. I'd love to hear from you…when I am not napping.

Thank you again for reading this book.

Rick

Rick Sammon

WHAT'S NEXT?

S o my friends, "What's Next?" Well, now it's time for you to digest and apply what you've read on the preceding pages and begin a new, exciting and rewarding chapter in your digital photography life. Good luck and as always, have fun!

I'd love to keep in touch with you, and I hope you can keep in touch with me. Here's how:

MY WEBSITE
www.ricksammon.com

ON FACEBOOK
https://www.facebook.com/RickSammonPhotography

ON TWITTER
https://twitter.com/ricksammon

ON INSTAGRAM
https://www.instagram.com/ricksammonphotography/

MY PODCAST
https://picturingsuccess.com

Hey! If you feel as though you got a lot out of this book and know someone who could use some Photo Therapy Motivation and Wisdom, please spread the word. You can also spread the word by posting a review on amazon. Click here to write a review.

Finally, a big "Thank You" for spending some time on these pages with me. I truly appreciate it!

CPSIA information can be obtained
at www.ICGtesting.com
Printed in the USA
BVHW032010210721
612567BV00006B/209